SECRET
STOKE-ON-TRENT

Mervyn Edwards

AMBERLEY

First published 2016

Amberley Publishing
The Hill, Stroud
Gloucestershire, GL5 4EP

www.amberley-books.com

Copyright © Mervyn Edwards, 2016

The right of Mervyn Edwards to be identified as the
Author of this work has been asserted in accordance
with the Copyrights, Designs and Patents Act 1988.

ISBN 978 1 4456 5359 4 (print)
ISBN 978 1 4456 5360 0 (ebook)

British Library Cataloguing in Publication Data.
A catalogue record for this book is available from the
British Library.

Typesetting by Amberley Publishing.
Printed in Great Britain.

Contents

About The Author

Mervyn Edwards is the author of seventeen published books on North Staffordshire history and is a weekly columnist for *The Sentinel*'s *The Way We Were* nostalgia magazine. He has appeared on BBC One's *The One Show* and *Twenty Four Hours in the Past*, and is a familiar voice on Radio Stoke. He was a local history tutor for the Workers' Educational Association for eight years and helped to develop the education department at the now defunct Chatterley Whitfield Mining Museum, where he often acted in period drama for school groups.

Mervyn runs an annual history programme in North Staffordshire and is the leader of the Green Door history presentations which promote social wellbeing in a friendly environment. He is the entertaining emcee of Burslem History Club and a member of the Potteries branch of the Campaign For Real Ale (CAMRA).

Outside of local history, Mervyn enjoys power-walking and jogging. He has completed seventeen Potteries Marathons and other races, and in 2014 completed his first Mow Cop Killer Mile in thirteen minutes. He has completed several long-distance charity walks, sometimes in his beer bottle costume. In 2005, he was the pacemaker for mining historian Keith Meeson on a 60-mile walk of former colliery sites, helping to raise money for the Donna Louise Trust.

Introduction

Back in 1989, I began to research the history of North Staffordshire with a growing fervour, but before trawling the archives I made it my business to find out what local history publications were in the bookshops. After all, those who had gone before might offer me a decent overview of our area's development. In those days, the local interest shelves were not replete with titles as they are today. However, I feel that the launch of *The Sentinel* newspaper's *The Way We Were* nostalgia newspaper on 15 July 1989 did much to ignite an explosion of interest that is manifested today in bookshelves that positively creak beneath the weight of material on the people and places of North Staffordshire.

Very few writers have attempted to put together a full-blown, compendious and readable history of the origins and development of Stoke-on-Trent and its environs: a volume with organising principles and an engaging narrative that informs and beguiles the reader, and perhaps attempts to offer a different slant on the known history of the Six Towns.

We are still waiting for some brave soul to walk in the footsteps of John Ward, Ernest Warrillow, et al and write a modern history of the city – and *Secret Stoke-on-Trent* is certainly not it.

This book has been commissioned by Amberley Publishing as our take on the city's 'history below the surface' – and is based on the premise that there is history we know and history we don't know. For all those readers tired of reading that Wedgwood, Brindley and their associates met at the Leopard in Burslem in 1765 to discuss the Grand Trunk Canal project and for those who yawn at the constant repetition of facts that appear from one volume to another, this book is hopefully a breath of fresh air.

It presents ephemera – quirky, shocking, amusing, eyebrow-raising nuggets that may elicit in the reader the response: 'Well! I never knew that!' It does not purport to be yet another book about North Staffordshire myths and legends, because my standpoint is that fact can be far more jaw droppingly strange than fiction.

Then again, what is fact? Letters to *The Way We Were* over the years have asked about the whereabouts of 'Tickle Belly Entry' in Burslem – or a spot called 'Macalonie' on the Trent and Mersey Canal near Etruria. Likewise, where was 'Bucknall Sands' – and while we're in that area, what were the Pickled Onion Wakes?

The recollections of older people differ according to the accuracy of their memories and according to the time they were born. Recollections of an old pub may contrast significantly, depending on whom you are asking. Someone born in 1950 may not agree with the memories of another born in 1945 – not because of misrecollection, but because of different interests, attitudes and perceptions. Yet I hold that the value of oral testimony should never be underestimated. As *The Way We Were* has proved many times, if you want to know why older people had particular rituals, or knew locations by certain names, you have to ask older people. Take this letter from Paul Mifflin who lived in Whieldon Road, Mount Pleasant, in the 1950s and 1960s (published on 22 November 2014):

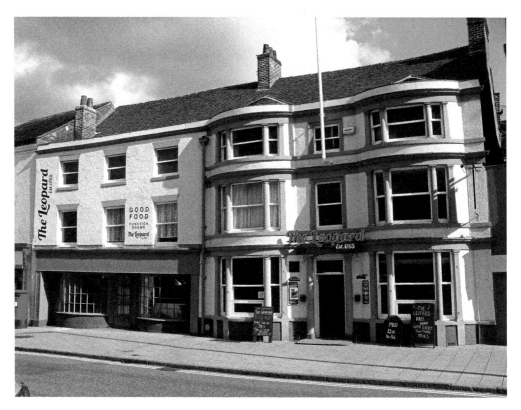

Leopard, Market Place, Burslem, 2014.

MADAM.- I am responding to Mervyn's Memories in The Way We Were on November 15. The reason Whieldon Road was called Teapot Row was because everyone in the road put a fancy teapot in the front window to display it, hence Teapot Row.

People who lived in Mount Pleasant were also called Monkey Landers because they supposedly used marl instead of soap.

When soap was on ration they used to get it from a marl pit in Whieldon Road, where the current FWB site is now...

While we are on the subject of *The Sentinel*, the accompanying photographs depict a wayzgoose – but what on earth was that?

It is defined by one source as an annual summer dinner or outing held by a printing house for its employees.

The Sentinel Composing Room Companionship Wayzgoose ran for many years and involved charabanc trips to some distant location – Blackpool was a particular favourite. In due course, protocol was relaxed a little, and staff members from other departments were able to join the printers.

The 'nuggets' in the following chapters are all sourced from newspapers, maps, plans and other official documents and are the result of twenty-six years of research. I can't take you on a wayzgoose, but hopefully you will enjoy the ride!

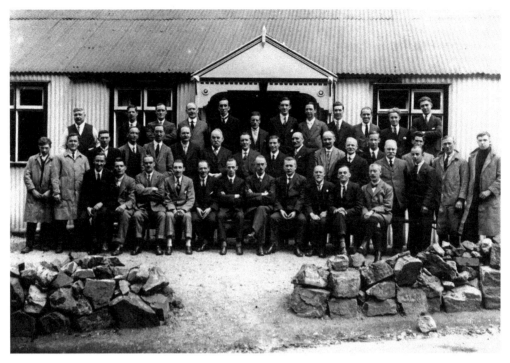

Sentinel Companionship Wayzgoose at The Wrekin, Wellington, 1923.

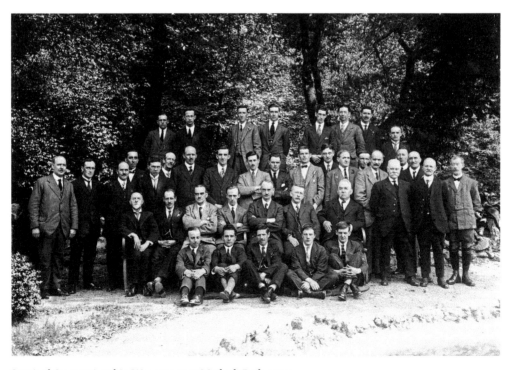

Sentinel Companionship Wayzgoose at Matlock Bath, 1924.

Communications

Irresponsible driving has been around as long as the roads themselves, as is proven by the following cases.

The *Staffordshire Mercury* of 1846 referred to the reckless practice of coal-carriers in trying to procure 'first-turn' at Kidsgrove – an example of road hoggery also referred to by the historian Warrillow. However, the business of street-racing is also mentioned in the same year. A phaeton accommodating a lady and gentleman, and a light car carrying gentlemen, were observed setting off from the covered market in Market Place, Burslem, with the phaeton just ahead. Opposite the Marquis of Granby, it was overtaken by the car, but took the lead again as they passed the Duke William. Afterwards, the horse-drawn vehicles both hurtled down Newcastle Street towards Dale Hall, and out of sight. The matter was passed on to the courts, and the proprietor of the phaeton charged with furious driving under the provisions of the Highway Act. His solicitor excused his behaviour, citing a restive horse and stating that the race was purely accidental. However, witnesses saw the situation differently. Joseph Bailey refuted that the race was an accident, as he had seen the riders 'flogging one against the other' as they passed and repassed each other. John Sayers saw both vehicles pass the lamp post at the top of St John's Square at tremendous speed, flogging furiously, and he was 'hard pressed to get out of the way'. The phaeton owner's solicitor argued in vain that the race had been an accident, and his client was ultimately fined for his part in this 'novel kind of racing at Burslem', described in the *Mercury*.

Stoke-on-Trent's brooks and streams helped to power watermills and necessarily enter our chapter on communications. Local place names such as Hanford, Ford Green Hall and Fenton all allude to the proximity of water – but on some occasions, it was a case of 'water,

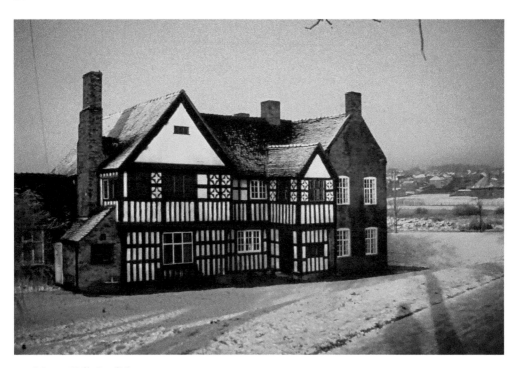

Ford Green Hall, Smallthorne.

Wedgwood's Etruria Works, overlooking the Trent & Mersey Canal, probably early 1960s.

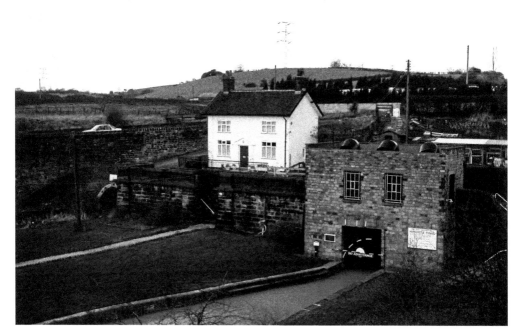

Harecastle tunnels, Kidsgrove, probably 1970s.

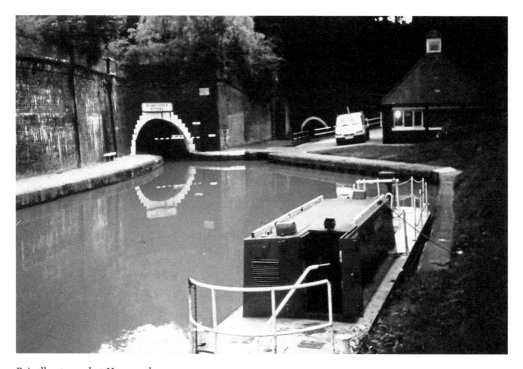

Brindley tunnel at Harecastle, 2000.

water, everywhere, and not a drop to drink'. Many areas were prone to flooding in severe weather conditions, as was seen in October 1846. Heavy rains inundated the lowlands on the banks of the River Trent and it was reported that 'The lands in the neighbourhood of Bucknall, Botteslow, Hanford, and Trentham present the appearance of one vast sheet of water, of considerable depth.' Many of the corn mills on the Trent ceased to operate on account of the superabundance of water. Liverpool Road in Stoke was flooded and several houses at Vale Street could only be approached by planks, the houses themselves being flooded to a depth of nearly a foot. Further north, conditions were just as bad:

> At Longport this morning, the brook which usually creeps along the valley so unostentatiously, assumed all the importance of a navigable river. On the low part of the road at Port Hill foot passengers were carried across in carts, or on the backs of men. Burslem was unapproachable by the fields from Wolstanton, without undergoing the misery of a cold bath on the eve of November.

Stoke-on-Trent's canals have seen many tragedies over the years, particularly where bridges and railings were absent or inadequate, posing danger to the public. In 1835, the child of Benjamin Turnock, a wheelwright of Stoke, was following his father to the Wheat Sheaf Inn, when the youngster fell into a sink that received the filth from the different drains near the canal. The child suffocated and died. What's interesting here is the laxity of the local authority in not improving safety at this spot. The *North Staffordshire Mercury* reported that 'this is about the third or fourth instance of children falling into it'. There was another danger spot on the canal at Boothen, where the council were finally forced to erect a swing bridge in 1904, having been handed a petition by concerned Stoke residents that 'measured three yards long'.

The demise of Timothy Trow, a young tramcar conductor, who perished while attempting to save a little girl from drowning in the Newcastle Branch Canal, passing through Stoke, in 1894, is well-known – not least because a monument in the West End of Stoke reminds us of the incident and of the waterway itself, few traces of which now remain. However, there are countless other recorded but long-forgotten accidents involving our canals, occurring through the carelessness or stupidity of the public. William Myatt, a collier by trade, had previously fallen into the Newcastle Branch Canal, but managed to do so again in March 1916 after being seen 'staggering' home from the Wellington pub in the west end of Stoke.

Other individuals escaped death by the skin of their teeth, as was the case of the intoxicated Thomas Johnson in 1846. It was his good fortune that a policeman was walking along the towpath on the canal near to the Wheat Sheaf Inn in Stoke, when he happened to see a hat floating on the water. On attempting to reach the hat, he saw the arm of a man make an appearance just below it. The constable immediately seized hold of the arm and drew Johnson to terra firma, saving him from certain death. A press report stated, with due equanimity, that 'The defendant expressed himself thankful for being thus rescued, and promised to present the policeman with a small reward for his kind interference.'

Some poor souls perished in the murky waters of our local canals by their own choice. Ralph Davies, a one-legged man of Bowden Street, Burslem, had been suffering from illness

and depression for some time. In 1927, having gone without sleep for a week, he left home, informing his sister that he was going to take his own life – and was not to be dissuaded. Subsequently, his body was recovered from the canal at Middleport, with an attached note: 'I am giving my life in.' A verdict of suicide while of unsound mind was recorded.

More unusual is the following story from April 1932, concerning star-crossed lovers. Colin Caxton, aged twenty-seven, was a married man with four children, who, about four years previously, had sustained a head injury while working at Fenton Colliery, and who had since complained of pains in his head. To what degree this had affected his judgement is unclear, but upon securing alternative employment at the Doric Pottery in Longton, he met Barbara Chadwick, a twenty-one-year-old apprentice and a single woman. They began to 'walk out' together and developed a relationship that eventually came to the attention of Mrs Caxton, who remonstrated with her husband – to no avail. Referring to the girl, he informed her, 'When I go we will go together.' He evidently did not intend to give her up, though further admonitions from Mrs Caxton and Barbara's relatives led them to believe that they had persuaded the lovers to end their affair. However, on 10 April Coxon left his Longton home and was not seen alive again. Barbara also left her home, suggesting that she was going to see a female friend. Six days later, their bodies were found in the canal at Sideaway near Fenton – secured together by means of leather straps. The decomposed bodies were hauled out with a shunting hook by Samuel Hand who had found the pair with their arms around each other, strapped together. Police sergeant Benbow told the coroner's inquest at Fenton Town Hall that 'they were bound together in such a way as to suggest that they meant to die together'.

Over the years, some historians have come to be recognised as specialists in particular areas. They are sometimes dubbed obsessives or anoraks by cynics, but this is a backhanded compliment – you can't argue with the pains they have taken in researching their chosen subject. There are brewery experts, pub experts, medical experts and Titanic experts – 'Titanoraks' as they are labelled today – but for minutia and a fine-toothed comb, you'll never ever beat a railway expert. There are a small number who have covered railway developments in North Staffordshire, and their published works offer a magnificent feast of facts, statistics and other information. However, relatively little information is available concerning the social history associated with the Railway Age, and the people who metaphorically and literally laid down its tracks.

It's accepted that the railway navvies were shunted around the country, constructing the railway lines that, in time, would make Britain a smaller place. A hardworking, hard-living closed community, the navvies must have seemed almost alien to the inhabitants of the Potteries, themselves sometimes known for their insularity. So what happens when two worlds collide?

There were various newspaper reports concerning disturbances involving those working on the North Staffordshire Railway line in the late 1840s. In 1847 it was stated that those navvies working in the vicinity of Tunstall were creating so much disorder on the streets that the town's police were barely numerous enough to curb their excesses. In October of that year, Tunstall police court discussed a riotous Saturday night disturbance that involved over thirty individuals, a mixture of navvies and young Tunstall potters – but who were the villains of the peace at the time of these turf wars? The *Staffordshire Mercury* declared:

Cobridge railway station, date unknown.

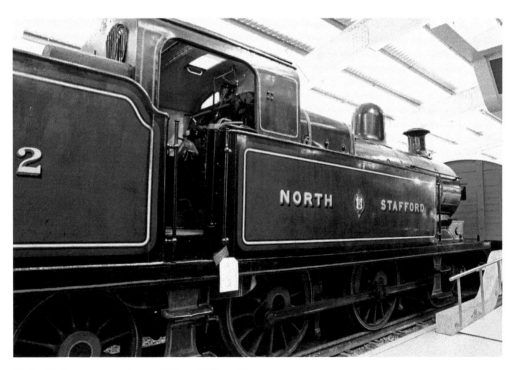

North Staffordshire engine at Shildon Railway Museum, 1994.

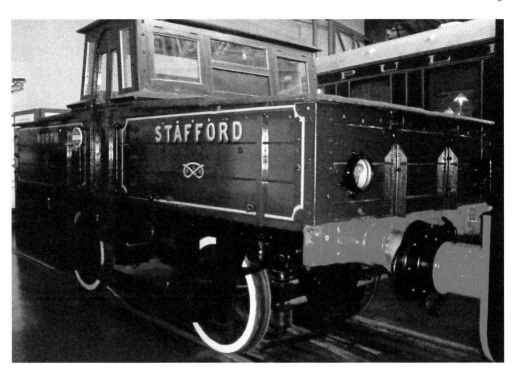

North Staffordshire vehicle at the National Railway Museum, York, 2011.

Tunstall has for some time past sent to the police-courts, a great number of disorderlies than any other town in that part of the Potteries. It was hoped that the stringent clauses and heavy penalties imposed by the 'Improvement Act' passed in the last session of parliament – penalties from which the Tunstall disorderlies had previously been exempt for want of a local act – would have checked these constantly recurring disturbances. But alas! For the peace of the well-disposed portion of the inhabitants, these expectations have yet to be realised.

The *Mercury* questioned whether young Tunstall men were overly confrontational or whether the town's ale was too potent. Either way, the peace of the town had been disturbed for many months, and the court case of October 1847 described the disruptive scenes around Roundwell, Market Place and neighbouring streets. Whether done for a lark for the sake of annoying the police or not, the sporadic disturbances tested the mettle of the Tunstall lawmen, who found it difficult to clear the town of the wrongdoers and struggled to round up the ringleaders. The magistrate, Mr Rose, commented that,

There might be a doubt whether this disturbance was a riot, in point of law; but there could be no question that it was so in point of fact; one of the officers had stated that he had not seen such a state of things in the Potteries since the riots of 1842.

This was not the last time that trouble flared between the railway navvies and local residents, and the following case from 1867 gives us some insight into the outsiders' ways. At a place near

to Talke-o'-th'-Hill, a farmer killed a navvy who had been employed on the railway in course of construction nearby. His brother navvies, residing in huts along the railway line, were stricken with grief, and following the burial they raised a fund and engaged a solicitor to conduct the prosecution at the ensuing manslaughter trial. However, the farmer was acquitted at Chester assizes, returning to his farm to gather in his neglected crops. One night, with the weather threatening, the farmer enlisted extra help to bring in his crops, and among the men was a railway navvy. When the other hut-dwellers heard that their enemy, the farmer, was being assisted by one of their own, they obtained horsewhips and walked to the farmer's field. Finding their renegade brother, they flogged him all the way from the field to their huts, where they held a court for his trial. Throughout, he was held by two burly navvies, while a third stood behind the terrified prisoner holding an axe over his head. A newspaper report summed up:

> The guilt of the culprit was fully made out, and the penalty imposed was instant payment for sundry gallons of ale, with a further proviso that if the culprit ever again should help the slayer of their departed comrade he should have his head cut off.

One man did in fact lose his head, in a bizarre incident on the rails in 1893. In July of that year, commuters waiting on the platform at Longton railway station must have had the shock of their lives. The Derby train arrived on time at 12.16 p.m., with a man's severed head on the front part of the engine. Upon inquiry, the rest of the body was found in the nearby Meir tunnel at Normacot and quickly moved to the Millfield Hotel. The resultant coroner's inquest concluded that Isaac Hall, forty-three, a dish and bowl maker, had been knocked down while walking – rather foolishly – through the tunnel. There was no evidence to suggest he was trying to kill himself, hence the coroner's verdict of 'accidental death'.

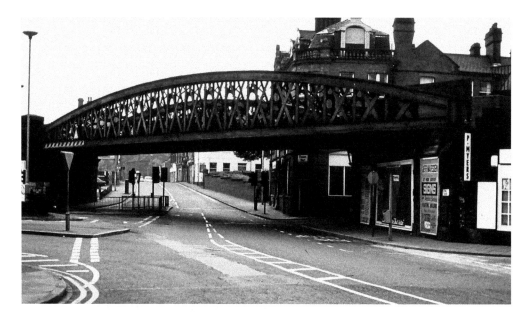

Longton railway bridge, probably 1970s.

Industry

Did You Know?

Many miners worked hard and played hard – few more so than two from Whitfield Colliery near Tunstall. They took part in a prizefight, 2 miles away from Biddulph Church, in 1886, for £2 10s a side. James Guye, aged twenty-eight, and Samuel Dawson, sixty-four, slugged it out for over two hours and forty-five rounds. Dawson eventually broke his wrist while striking his opponent and lost the prize. Neither men were fit enough to return to the pit the day afterwards.

The owners of one pottery manufactory preferred their coal supply really close to home. Adams' Greenfield Pottery in Furlong Road, Tunstall incorporated a small colliery, as indicated on Hargreaves' map of 1832. It was operated solely for the purpose of providing fuel for the pottery ovens, and its headgear was later a familiar sight to travellers on the Loop Line railway between Tunstall and Pittshill.

In 1947, Mr N. Newton from Lightwood miraculously escaped death when his lorry toppled over the edge of the marlhole at Wheatley's tileries, Springfields, Trent Vale, while he was sitting in the driver's cab. Mr Newton was bringing clay to the tileries. The lorry was being loaded when it started to move, slipping over the edge and falling to the bottom of the marlhole. The lorry was badly damaged and the driver's cab was smashed, but apart from a few cuts, Newton was unhurt. When asked about his experience, he replied, 'That little episode is not worth bothering about.'

If some of the big names in ceramic manufacture were long-lived, the same cannot be said for their employees. Occupational health remained a significant issue in the pottery industry long after the Factory Acts and other legislation had improved conditions in the workplace. Even as late as 1950–59, almost 800 pottery workers died, with pneumoconiosis as the primary cause of death. Even more disturbingly, 2,421 new cases were diagnosed over that same period. So-called 'dust disease' often worked by stealth, did not become a problem to the sufferer until years afterwards.

In the nineteenth century, those potters who lived beyond their forties were the lucky ones – although one major employer was eager to celebrate the longevity of its workers.

Wedgwood's factory in Etruria held celebration dinners for its workers, these being an exercise in both congratulation and self-congratulation. They usually stressed the harmonious relations between masters and the sometimes aged men who had not fallen prey to potters' rot, lead poisoning or any other occupational hazard. In 1864, Charles Adams,

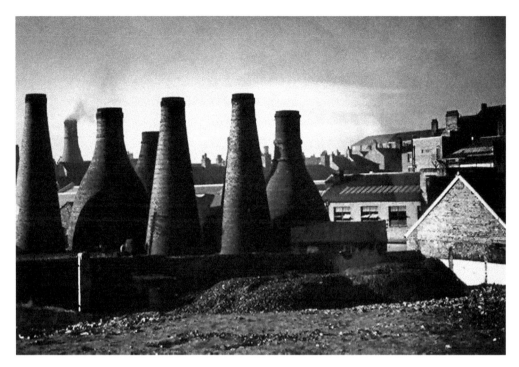

Acme Marls, Burslem, 1955.

Alcock's factory, Westport Road, Burslem, probably early 1960s.

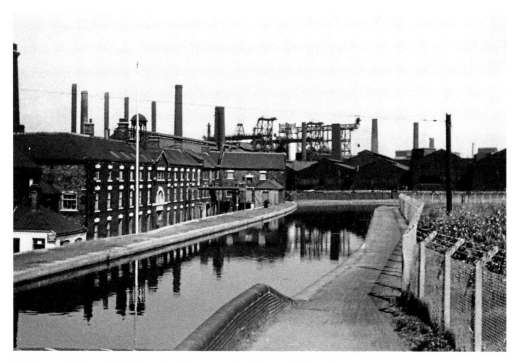

Wedgwood's Etruria Works and adjacent steelworks, probably early 1960s.

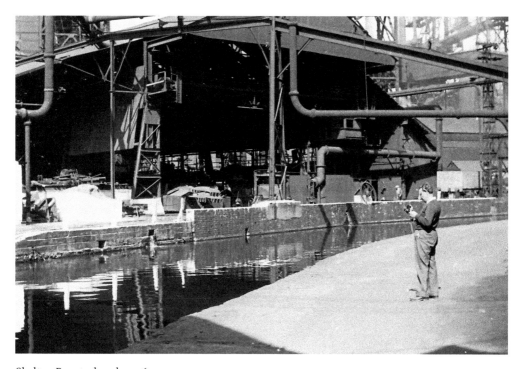

Shelton Bar steelworks, 1960s.

James Mason, George Pickering, John Ellis and James Dean – all of whom had worked for the company for fifty years – were honoured by a celebratory dinner that was also attended by several members of the Wedgwood family. Another four men were also honoured, their length of service ranging from fifty-four to sixty-nine years. Mr Adams spoke of his own family's service to Wedgwood's: His father had clocked up forty years; he himself fifty-three; and his brothers William, sixty-one, John, fifty-five and James, thirty-eight – a total of 247 years and counting. In addition, his first wife had managed thirteen years, his second wife, thirty-seven and his third wife, fifty-two years. For good measure, his two sisters and son between them had given sixty-two years' service.

Some of the old-timers worked until they dropped. William Adams, of Etruria, died aged eighty in 1873, having worked for Wedgwood's for seventy years. For fifty of those, he had occupied the position of foreman in the Oriental department.

Other men associated with industry in Etruria lived far shorter lives, sometimes for tragic reasons.

John Helmore was a furnaceman at the Etruria Ironworks who committed suicide in 1871. Having worked at the furnaces for around four years, he had been a noted drinker, but had signed the pledge six months earlier. However, he had slid back into old habits and had been suffering from delirium tremens. One day, in a state of infuriated madness, he declared that a murder would be committed before the day was over. Later, he went to the top of one of the blast furnaces, and, carefully placing his hat and two purses containing some sovereigns to one side, deliberately threw himself into the almost white-hot fires. The furnace was subsequently turned off so that some of his remains might be recovered, but he had been totally consumed, an episode that created a great stir in the neighbourhood. Another furnaceman, Alfred Perrins, twenty-nine, fell into a furnace at Shelton Iron, Steel and Coal Co.'s works in 1916. Upon his body being discovered, it was found that his whole body from the chest down had been calcined. It was thought that he had been knocked out by his fall, before dropping into the surface, so at least Perrins was spared the torture of being burnt alive while still conscious.

Another notable employer in Etruria was Wenger's colour works, where another horrendous death took place in 1928. William Meadon, a colour grinder, got his clothing caught in the shafting that drove some of the grinding machinery. His horror-stricken colleagues saw Meadon whirled around the shafting, and when the engine stopped, he was quite dead.

Stoke-on-Trent was built on clay and coal – and this can be taken literally. In recent years, teams from the archaeological department of the Potteries Museum have carried out countless excavations that have unearthed old pottery on key sites in the town. Among those sites, we might mention the location occupied by the present Swan Bank Methodist Church (consecrated in 1970), Woodbank Street, and the rear of the nave of St John's Church on Baptist Street. Sub-surface pottery? 'Twas ever thus in industrial Burslem.

When Port Vale's new football and recreation ground was being built in a field near to the Loop Line railway station in the mid-1880s, old pottery was found at a depth of 6 feet or so below ground. The glazed, brown pottery ware articles were made of local clay and were described as 'crudely ornamented'. These 1884 excavations revealed a large jug with a small handle, various handled mugs and drinking cups, a porringer, pieces of dish and a

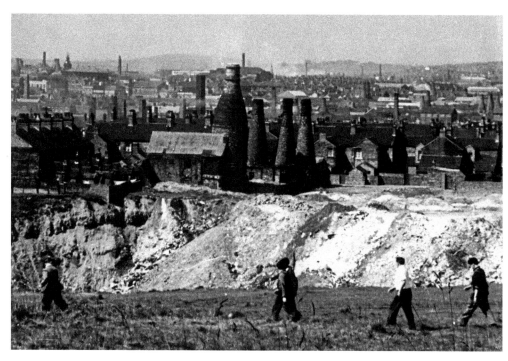

Industrial Burslem from Sneyd Street, Cobridge, 1957.

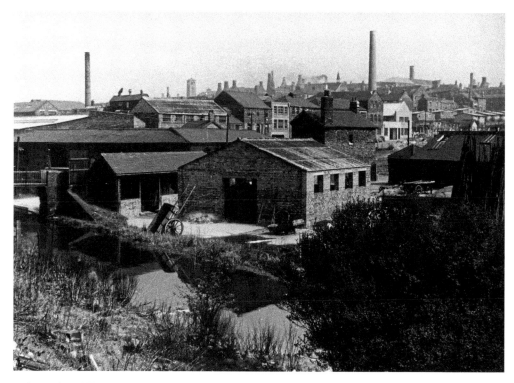

Industrial Middleport, 1961.

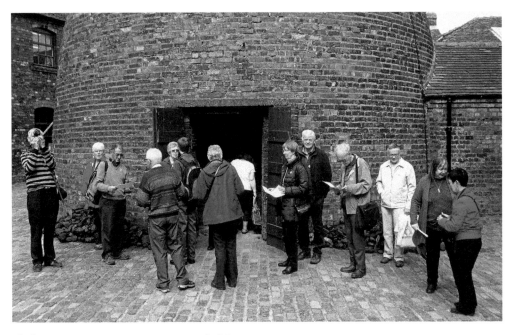

Gladstone Pottery Museum, Longton, and visitors, 2014.

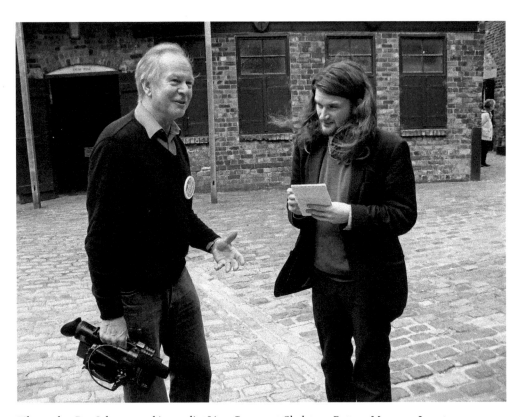

Film-maker Ray Johnson and journalist Liam Barnes at Gladstone Pottery Museum, Longton, 2015.

few shaped jars. A local newspaper reported that it was 'evident that these specimens belong to the oldest period of local ceramic art when only native clays were used'. All the pieces seemed to have been hand-dipped by potters and held upside down by them. Fingerprints were evident on many, whose bases had been left unglazed. Predictably, many of these items were damaged, but others were recovered in nearly perfect condition. Port Vale's new ground was being constructed at the expense of Mr Bew, who kept the New Inn pub in Market Place, and he volunteered to show the ceramic discoveries to interested parties. He planned at the time to present the items as a gift to the Wedgwood Institute Museum.

It's also worth mentioning that tygs – i.e. large pottery mugs, boasting handles – believed to have been made by a mid-seventeenth-century pottery, have been discovered on a site on or near to the Marquis of Granby pub (now the Saggar Makers) in Market Place. This pub replaced an older version of the same name in 1958, when what lay below the land had become a significant problem. The hostelry had suffered minor tremors through subsidence and the floor had become uneven with cracks inches wide.

Coal was inescapable. During excavations on the site of the Theatre Royal in Pall Mall, Hanley – the rebuilt venue opened in 1951 – it was found that the old theatre had been located over coal workings that were estimated to be around 200 years old. In 1963, when the new Lewis's department store was being constructed off Stafford Street, workmen found a layer of coal and rubble around 3 feet thick on site. Many tons of the same were taken away, and a quantity of the coal was quite usable.

There was certainly a price to pay for the economic prosperity that had been created in Stoke-on-Trent on the back of the coal industry, sometimes leading to legal battles between colliery proprietors, landowners and local residents.

In 1847, an interesting legal tussle was fought between William Hilton and the mighty coal and iron master, Earl Granville, who leased his mines in Hanley and Shelton from the Duchy

Sneyd Colliery, Burslem, mid-twentieth century.

Sneyd Colliery spoil tip from Leek Road, Sneyd Green, 1959.

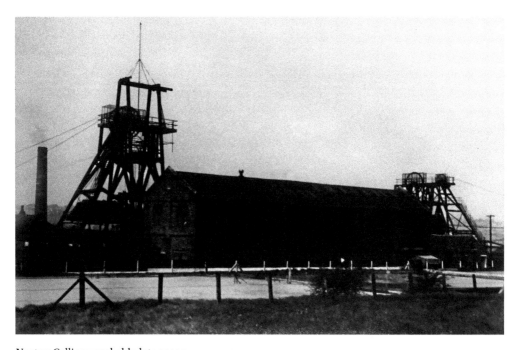

Norton Colliery, probably late 1940s.

of Lancaster. Following the extension of Granville's operations in 1841, the foundations of numerous houses had given way, with the result that several houses had cracked, tottered and collapsed, thus precipitating legal action against the industrialist. By 1847, it was reported that 'upwards of 160 [houses in Hanley and Shelton] are either uninhabited, or so propped up as to be dangerous to reside in'. Hilton was the owner of two damaged houses in Union Street, and he pushed for compensation. This long-running case was eventually taken to the Court of Queen's Bench in London, with the *Staffordshire Mercury* reminding its readers that while houseowners had a right to foundations that were not rendered unstable through undermining, Granville's operations had been crucial in creating Hanley's prosperity. Thus was a major employer able to exercise power in high places. The influence of today's big businesses shows that little has changed from the nineteenth century.

Hanley Town Council clashed with Earl Granville repeatedly. His agent, Mr Wragge, commenting on the damage to surface buildings in 1883, averred in a letter that 'in every case where serious dilapidations of buildings have become apparent, the property is very old, and naturally decayed; and if mining operations have had anything to do with accelerating the decay, they are probably of a very remote date.' This view, incidentally, drew laughter from the town councillors. The council had a valid interest in these affairs, as it was losing rate revenue from those houses that had become untenanted through damage. Footpaths and kerbs also had to be repaired. The *Staffordshire Knot* newspaper repined that 'if property may be injured with impunity it would appear as though part of Hanley might suddenly subside into the "Big Pit."' Was it necessary, asked the organ, for Granville's mine workings to come so close to the surface?

However, it was difficult to prove accountability. In 1914, subsidence caused by mining operations was found in Hanley Park, persuading the council to raise objections with the Shelton Iron, Steel and Coal Co. The company repudiated any liability but consented, as an act of grace, 'to incur what they may consider to be a reasonable expenditure in connection therewith'.

For some people, subsidence was a problem that was too close to home; but for Miss Annie M. Harding, aged twenty-one, subsidence occurred in the home. She was the step-daughter of Mr Sheldon, a clerk to the Burslem School Board, and in 1885, she was crossing the scullery at Sheldon's residence, Blue Stone Cottage in Burslem, when the brick floor gave way beneath her. The lower part of her body disappeared below the floor, and Annie, who became unconscious, was luckily rescued by her brother. A subsequent inspection revealed that the floor had been built over a long-forgotten shaft. The cavity was empty for a distance of 4 yards below the surface, beneath which was 7 feet of water. Old wooden beams and a layer of earth had been used to cover the pit, but the timber having rotted, the earth had also given way, leaving the floor bricks unsupported. The *Staffordshire Advertiser* reported that had Annie fallen completely through the pit 'she must have met with a sad end'.

Danger was ever-present in the mines. Thousands of men were killed, but others survived accidents and were able to return to their duties. One Burslem man, Joseph Boulton, aged forty, had a miraculous escape from death in 1943 at Sneyd Colliery. Along with other maintenance workers, he was recapping a winding cable when he overbalanced, falling backwards and head first down the 600-yard shaft, his body turning several somersaults in its descent. At just after halfway, Boulton managed to reach out and seize an oil-covered

wire guide rope – literally, a lifeline. The local press reported that he had seen the rope glistening in the light reflected from the pit mouth as it swiftly disappeared from view. Managing to get a hand on the rope, he wrapped his legs around it for good measure. He was later rescued, and the press made much of his cool head and quick reactions. After some routine first-aid treatment, Boulton declared, 'It was the million-to-one chance that came off.' Mr I. W. Cumberbatch, the pit's managing director, stated that he'd never known such a miraculous escape in his forty years' experience of mining.

Other individuals however chose death over life. William Green, thirty-four, of Fegg Hayes, was a lamp man at Whitfield Colliery in 1895, and had for some time been exercising his mind over the matter of improving miners' lamps. It was stated that his intense study had unhinged his mind, and as a consequence, he jumped down a 40–50 yards deep disused coal shaft near to the Oxford Bridge at Fegg Hayes. He was remembered as a steady man and a total abstainer, the coroner returning a verdict of 'suicide whilst of unsound mind'.

Incidentally, reference was made to the fact that the old shaft had been 'well-protected', presumably through primitive fencing. What is obvious from no end of reports is that these hazardous pits were barricaded in the most cursory manner – as was witnessed in 1938.

Richard Butters, sixty-two, was a potter's crate maker living in Meir Street, Tunstall. He had not been well since his wife's death in 1932, and one Saturday afternoon, he was observed walking around Mayer's Fields near to several disused pit-shafts. His brother, Robert, being told of this, made haste to the fields and found Richard standing inside the fence that protected a shaft. Robert shouted, 'Come back, Dick, don't be silly,' but was told, 'You are too late, Bob, I am going.' With that, he jumped down the shaft to his death. He had evidently planned the suicide, as he had hung his waistcoat around the edge of the shaft and had tied to it a note which read, 'Goodbye all – Dick.' He'd also left a 10s Treasury note and scribbled instructions for the money to be given to a local Methodist church collection. The body was later recovered by police from the bottom of the 240 yards deep shaft.

Houses and Homes

The sumptuous houses of the great and good have a history that has been covered by many authors. Books such as *Potworks: The Industrial Architecture of the Staffordshire Potteries* (1991) by Diane Baker describe splendidly the broad spectrum of housing in Stoke ranging from middle-class housing to manufacturers' mansions and artisans' cottages.

Working-class housing has been the focus of commissions of inquiry and reports such as The State of Large Towns in North Staffordshire. Interpretation in the toilets gallery at the Gladstone Pottery Museum draws from some of the nineteenth-century reports as well as contemporary newspapers in painting a picture of what living conditions were like in our local towns prior to the sanitary revolution.

Photographs from the Blake and Warrillow Collections illustrate graphically how lower-class people lived in the nineteenth century, and their story often makes more interesting reading than the descriptions we have of middle-class housing. The town of Longton grew in such a higgledy-piggledy, unplanned fashion that ramshackle dwellings could be found a stone's throw away from busy factories and buildings that expressed aspiration or civic pride.

Lockett's Lane, in Uttoxeter Road, was one of the slum areas of Longton by the late nineteenth century. The Victoria County History records that 'in the Edensor district, in John Street (now Calvin Street), in Lockett's Lane, and in the area around St James' Church conditions in the later nineteenth century were probably as bad as anywhere in the Potteries'. It is amazing to think that St James' church, an edifice intended to uplift and edify the community, should have been hemmed in by such squalor.

Surviving photographs of the John Street area tell us much about its rude condition – but it is perhaps a secret to some as to why this dreadfully down-at-heel area took so long to be cleared.

Working-class privies mock-up at Gladstone Pottery Museum, 2013.

Short Street, Longton. Mervyn Edwards leads a Green Door history walk, 2014.

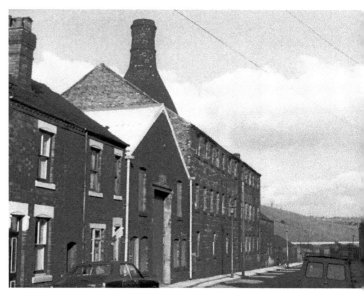

Above left: Lockett's Lane, Longton, probably 1960s.

Above right: Housing and industry in Chilton Street, Fenton, 1978.

The same view of Chilton Street, Fenton, 2014.

A newspaper report from 1928 certainly indicates the city council's concerns about this insanitary area. It was undoubtedly one of the worst slum areas in the city and many people hoped that it would be dealt with in the same fashion as the similarly rundown Massey Square in Burslem had been a few years earlier. This had been the first slum clearance scheme in Stoke-on-Trent. The council's town clerk reported that the John Street area consisted of around 178 structures, of which 163 were either dwelling houses or shops, the majority of which, built over a century ago, were in dilapidated condition. Sanitary conveniences were almost entirely absent, and there was horrendous overcrowding, with thirty-nine houses to the acre. The death rate for children in the area was far worse than in other parts of the city, partly because of the narrow, dingy streets and the large, polluting factories surrounding.

This inquiry was made in conjunction with a Ministry of Health inspector, under the provisions of the Housing Act, statistics on living conditions in John Street being prepared for the council by their medical officer of health. Theoretically, swift demolition should have been a racing certainty. However, the newspaper report of these proceedings indicates that the councillors had anticipated stiff opposition to the clearance scheme from 'one of two licensed premises in the area'. It is fascinating that given the squalid conditions of John Street, the contentions of capitalists should nevertheless have held sway. Upon the resumption of the inquiry, several solicitors appearing for the owners of property situated in the area, addressed the inspector, arguing that insufficient evidence had been given to show that the area was insanitary and that 'the demolishing of the property would entail serious hardships upon the owners and upon business people who live in the area'. After witnesses had been called for the opposition, the inquiry was closed. The clearance of John Street would have to wait at least a little while longer, and decay would continue to reign.

History may record the John Street area of Longton as one of the most notorious squalor blackspots in the Potteries, but there were other areas where those at the lower end of the

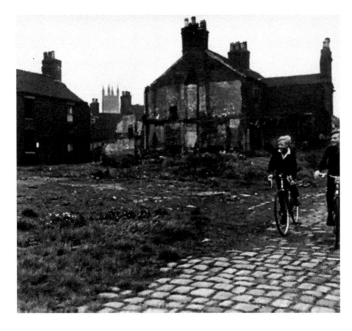

Burslem compulsory purchase order area, 1961, showing tumbledown properties.

social pyramid lived roughly in primitive dwellings. Charles Shaw writes in *When I Was A Child* (first published in book form in 1903) of the Hole House area of Burslem.

However, Mervyn Jones in his *Potbank: A Social Enquiry Into Life In The Potteries* (1961) is one of the few writers ever to mention Bostock Street in Hanley, which by that time, no longer existed 'except as a name on a wall'. Jones describes a roughly-levelled square of waste ground in the Bryan Street area of Hanley, and the adjacent slum dwellings, rustic outhouses and tiny gardens.

A trawl through the local newspapers in the late nineteenth century reveals many of the horrors of this hellish backwater of Hanley. Bostock Square, Bryan Street, was often mentioned in the newspaper reports from the 1860s.

Police court reports in such as the *Staffordshire Times* were often headed, 'BOSTOCK SQUARE AGAIN,' and the area was regularly described as 'notorious'. It was known for drunkenness, disorder and prostitution and many of its inhabitants showed scant respect for the long arm of the law. In 1867, it was reported that the conduct of residents was so outrageous that police superintendent Baker had been obliged to double the number of constables on the Bostock Square beat – one of his men having been beaten very severely. Two years later, two Irishmen, John and Thomas Carroll, who had previous convictions against their names, were having a drunken Saturday night row with some other men in a nearby street. Constable Moore intervened, only to be thrown on the floor by Thomas. Michael then seized his staff from him and struck him with it, prompting Superintendent Baker to state at the hearing that he 'was certain there would be a murder in Bostock's Square one day'. Ellen Carroll – presumably a relative of the two brothers – also lived in Bostock Square and was evidently just as volatile. In 1885, she broke twenty panes of glass in a neighbour's house, and then threw several cups and saucers from her own house through one of the broken windows of his domicile.

The prostitutes in Bostock Square were also to be avoided if a press report of 1869 is to be considered. Edward Barker, of Fenton, fell prey to their dubious charms, treating Matilda Simpson and Eliza Onslow to drinks at a Hanley pub prior to accompanying them to Bostock's Square. While in a room with the two prostitutes, he was shocked when half-a-dozen other people rushed into the room. They threw him to the floor, abused him and rifled his pockets and stole a watch and other personal belongings. With blood streaming from his mouth, he managed to reach a police station, and reported the matter. Possibly against his better judgement, he returned to the house with a policeman, only to be struck in the mouth again by Matilda.

Such were the joys of living in one of the most depraved areas of the Potteries in the late nineteenth century. However, Victorian living conditions endured long beyond the death of Queen Victoria in 1901.

Photographs in the Penguin Books version of George Orwell's *The Road To Wigan Pier* (1937) show working or lower-class people living in slum dwellings, insanitary huts and tin caravans. Such basic living was not unheard of in twentieth-century Stoke-on-Trent. A photograph in *The Sentinel* newspaper in 1925 shows the Smallthorne family pictured outside the railway carriage in which they lived. The caption stated that it was 'as comfortable a dwelling as many a working-class family could boast'.

Elsewhere, the number of poor families living in overcrowded areas of the city prompted external agencies to take action in 1936. In Church Lane, Goldenhill, twenty-six houses were erected by Church Army Housing Ltd – in conjunction with the City Council – as a response to the local housing problem. At the inauguration, Mr Bindloss, a member of the Church

Army Board, London, described how the Church Army, under the leadership of Preb Carlisle, had decided to start a public utility society in 1926 as an example to the churches and to other bodies. The aim was to give people on low incomes the chance to bring up their families in decent surroundings. There were 210 applications for the twenty-six properties, illustrating the extent of the housing problem in Goldenhill.

Not every house in Goldenhill had a reliable water supply, hence a protest meeting that was convened in 1939 with the hope of persuading the Potteries Water Board to improve its service to the northern end of the village. There, the matter of bathing and sanitary arrangements had become pressing. Councillor G. F. Barber told the meeting that he had been fighting this cause for three years, but had met with no positive response from the water board concerning the inadequate supply. It was all the more necessary, as Goldenhill at this time had 4,000 inhabitants and was a developing village. One of the meeting's organisers, Fred Hall, had taken what he called a private census in Goldenhill, and said that out of the 610 houses north of Church Street, only thirteen had baths, four of those had no water supply upstairs, and two had to pump water upstairs to have a bath.

On a humorous footnote, we should add that the meeting was chaired by the vicar of Goldenhill, who had taken the trouble to ask a number of people if they were coming to the meeting. They asked what the meeting was about, and the minister replied, 'water'. 'Oh,' they said. 'We never drink water.'

There was much primitive housing to be found elsewhere in the city, hence a report in the *Newcastle Times* newspaper of 1952 about the condition of the 'huts at Hartshill'. It was revealed that Pamela Vernon, aged seven, had been admitted to Bucknall Hospital, suffering from illness,

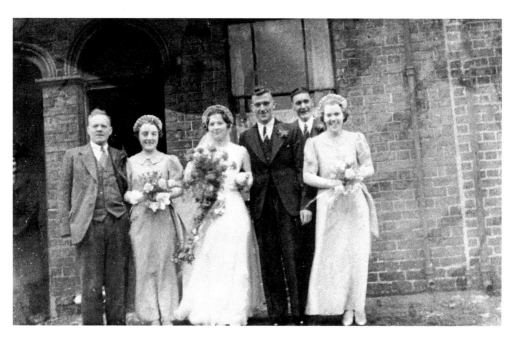

Pictured in 1940, No. 12 Victoria Street, Goldenhill, part of a terraced street. It shows the wedding of Nellie Oakes and George Brindley.

after spending the night in a ramshackle Nissen hut with snow drifting in from the broken roof. The hut was part of a camp of seventeen huts in the Hulme Street area that had already been condemned by the Medical Officer of Health for Stoke-on-Trent. The residents had been promised rehousing, but in the meantime only minor repairs had been made to these tumbledown shacks. The Vernons lived in what appears to have been the worst hut, with two other families.

Approaches to the council's housing department took a long while to bear fruit, though the Vernons were eventually granted a new council house in Meir. Those families forced to remain a while longer continued to suffer. Mr W. W. Eaton, the father of Mrs Vernon, of nearby Harpfields summed up the properties as follows:

> The whole camp is insanitary. There are communal lavatories and only two baths and two washing boilers. Windows in the bathroom are broken and men have to stand guard when their wives take a bath. The children are growing into 'Dead End Kids' in streets that sometimes run with filth from flooded drains. Families have made great efforts to make the damp huts homely, but they are losing heart after five years. Some were originally squatters in 1946 but others were tenanted here by the Corporation. They pay 10s. a week rent. They are decent people forced to live in conditions that are a black spot in a pleasant district.

This *Newcastle Times* story persuaded other voices to join in the chorus of complaints about the ex-army huts. Tenants reported that every night wet bedding has to be taken off and dried. The huts were so draughty that a baby's cot has to be surrounded with blankets. Coal was stored in living rooms, and fumes from the open stoves was affecting children's health. Elsie Byrne lamented that her son was due to have his tonsils out but that – unfortunately for the boy's throat – every time she stoked the fire, the room filled with smoke. She added that it was necessary to climb onto the roof every week to clean the flues – even though the roofs were unsafe. George Scott showed the newspaper's reporter his hut's crumbling walls, and a stopped drain 'where I have to get my hand down every week'.

The pride that subsists in even the most impoverished communities was evidenced in the reaction of some tenants to Mr Eaton's reference to 'Dead End Kids.' They declared that their children were raised as well as anybody's. However, the debate – and the publicity from the press – secured results. The *Newcastle Times* offices were visited by two of the hut dwellers who announced that all families had received provisional offers of a Council house. Overjoyed, they thanked the newspaper staff.

Not everyone chose to live in a conventional home. The Boswells lived at an address commonly given as The Caravans, North Street, Stoke. The family has periodically earned a mention in *The Sentinel* newspaper's *The Way We Were*, especially when the late, great John Abberley (1932–2010) was the editor. However, as fascinating as these nostalgic pieces were, you cannot beat contemporary press references if you are looking for a real flavour of the times.

John Boswell died in 1951, aged eight-seven. He was buried with ancient gypsy rites, all his belongings being burned including his caravan and bungalow. His wife's caravan was burned at the same time. It had not been opened since her death twenty-eight years previously. It was reported that from the day of John's death until after his funeral, all the neighbouring gypsies abstained from eating meat in any form – another old tradition. The service was in Holy Trinity church, Hartshill, with interment in Hartshill Cemetery.

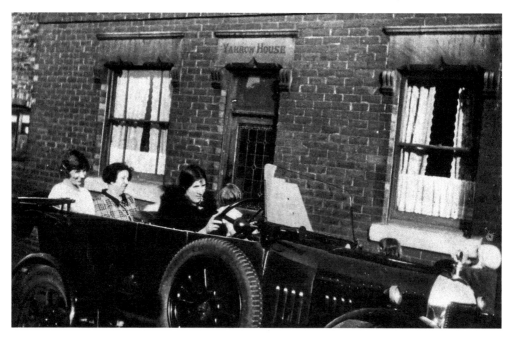

Yarrow House and the Lodge family, New Oxford Street, Penkhull, early twentieth century.

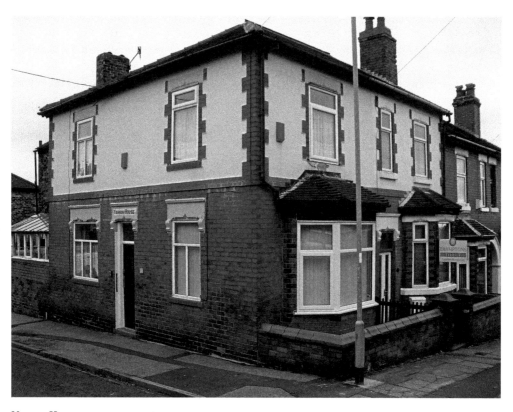

Yarrow House, 2014.

Health

The story of public health in the Potteries must necessarily embrace some reference to Asian cholera, which was a particular threat to life in the early 1830s – what we believe to have been the first case, having been discovered at Tunstall, in June 1832.

With much uncertainty in the Six Towns as to what caused cholera to spread – never mind how to treat it – local inhabitants were predictably nervous about this killer disease. What's fascinating is how ignorance and the agitation it triggered was exploited for the purpose of social control. In his *Sociological History of the City of Stoke-on-Trent*, Ernest Warrillow refers to a day of humiliation and prayer that was held in Burslem. It was observed through the closing of every shop, factory and public house. St John's parish church was filled by poor people, many of whom had suffered bereavement through cholera. The Revd Armstrong took the opportunity to expatiate on the degraded state and poor morality of the working classes, as if cholera had arrived as a means of divine punishment for their sins. However, our social betters had used such controlling tactics several years before the time of which Warrillow wrote. In August 1832 the *Staffordshire Mercury* reported:

Above left: Former Stoke Workhouse frontage, 1996.

Above right: St Peter's churchyard, Stoke, 2013.

STOKE WAKE commences to-morrow. As this annual festival is usually a scene of much dissipation, the Hanley and Shelton Board of Health have issued an address, cautioning all who value life and health, to abstain from intemperance during the prevalence of that pestilence, the Cholera, which has generally been found to break out with virulence after the occurrence of popular festivities.

The eventual discovery that cholera was primarily waterborne and the subsequent improvement in sanitary arrangements in the Potteries gradually neutralised its threat, though a later case of Asian cholera is reported in the local press of 1866. Ralph Smith was a forty-six-year-old house agent and inspector of the Stoke Market, and was well known in Stoke. Originally taken ill with what appeared to be diarrhoea, he was afterwards diagnosed by surgeon Holtom as suffering from cholera. Mr Holtom remained with Smith until his demise, but could do nothing for his patient. He was buried in Stoke churchyard and the funeral was attended by hundreds of people, many of them fellow businessmen. So much for the Revd Armstrong's notion that cholera discriminated according to social class.

In times past as well as present, newspapers and periodicals have advertised miraculous cures for a wide range of ailments and diseases, from cholera to cracked nipples. In the 1850s, the *Staffordshire Advertiser* printed various puffs for Cockle's compound antibilious pills, Ching's worm destroying lozenges and Widow Welch's pills for female complaints.

We're all familiar with the advertisements that embrace the recommendation of a former sufferer of an affliction, now cured by the application of some quasi-magical medicine. According

Mock-up doctor's surgery at Gladstone Pottery Museum, Longton, 2013.

to one notice in the *Staffordshire Advertiser* of 1914, this was the happy circumstance achieved by Mrs H. Sharratt of Burslem, who lived in the notoriously unhealthy Massey's Square. An illustration of this robust-looking lady accompanies the advert, which is headed, 'Burslem woman tortured for five years with leg ulcers. Frightful running sores banished by ZAM-BUK.' The notice revealed that Mrs Sharratt's legs were so itchy and ulcerated that she couldn't get her stockings on. Ordinary ointments and lotions had not been efficacious, and a doctor had told her that if she didn't go to hospital to have her legs scraped, then she might lose them. She subsequently attended the North Staffordshire Infirmary for three years – but then a neighbour told her about Zam-Buk medical soap. Upon applying this, she found that the burning sensation and the sores in her legs cleared up, and furthermore, 'as the discharge stopped, the ulcers gradually filled up with a firm, healthy fluid, over which Zam-Buk grew strong skin. First one leg and then the other was completely healed by Zam-Buk treatment, and I was able to walk again.'

The real or imaginary properties of a plethora of potions and pills were also promoted by quack doctors who would set up in public places in Stoke-on-Trent. This was a competitive business, and on occasions, the ministrations of such pill-peddlers annoyed professional practitioners or the marginally more qualified. In 1864, one local newspaper carried the notice: 'Caution. Beware of Travelling Quacks. Complaints have been made that there is a female impostor and some quacks calling round representing to be Dr and Mdlle Cavania.' Evidently, these individuals had been greatly inconvenienced by the operations of their

bogus imitators, and they offered a £3 reward for help leading to the conviction of these persons. This said, it was not unknown for some medicinal suppliers to insert notices in the local press accusing defrauders of imitating their products, while waxing rhapsodic about their product: 'Ask for Doan's Backache Kidney Pills, and be sure you get Doan's,' ran a solemnly worded notice in the *Staffordshire Advertiser* of 1914.

One itinerant pill merchant found himself in hot water in 1865. Having been allowed to occupy a stall in Burslem Market for some weeks, he ended up in breach of the by-laws for mounting his stall and promoting the properties of his pills in the most eloquent and stentorian tones. Other stall holders complained of his noisy hawking, but here was a fellow who evidently loved the sound of his own voice. He declared that he had fought the authorities in other towns and he would do likewise in Burslem. However, he ultimately found himself in the magistrate's dock and was fined for his ear-splitting oratory. Magistrate Mr Davis seemed to have little sympathy, remarking that if a stall refused him in future, a real disservice would be done to the public.

When pills and potions couldn't cure, there was always alternative therapy. Lectures on mesmerism at the George Hotel in Burslem and other pubs piqued the renowned curiosity of the Victorians in 1843. What was mesmerism? One form of it was practised by natural healers, who would lay hands in order to send people into a trance or sleep mode. This was a means of addressing nervous disorders. The author Charles Dickens had this ability, and was intensely interested in mesmerism, having discovered that he could send people into a 'magnetic sleep' by moving his hands across their heads and bodies. He is stated to have cured the caricaturist John Leech in this way.

However, when we discuss public health in the Potteries, we inevitably return to the subject of 'Smoke-on-Stench' – the blackening of the Six Towns through industrial pollution. This matter is often referred to in the newspapers as 'the smoke nuisance', but it is clear that the bottle ovens and chimneys that spewed out billowing clouds of smoke were not the inconvenience to some that they were to others.

The capitalist argument was summed up very succinctly by pottery manufacturer John Aynsley at the opening of Longton Park in 1888: 'They knew well that the noble town of Longton was smoky; but they generally considered in the town that where there was most smoke there was most cash (Laughter).' This view seems to have been echoed by Stoke-on-Trent County Borough Council in 1914, who, when challenged by the Nuisance Abatement Committee, responded unanimously, 'We want more smoke.' This was the response to George Barber's complaints about the smoke nuisance in Tunstall, whose residents had been advised to keep their windows wide open during the council's designated Health Week. If they did that, remonstrated Mr Barber, they would be poisoned by fumes.

Yet not everyone tolerated smoke emissions at this time, hence long-running arguments about smoke emissions and the coming of a succession of Potteries parks.

The Public Health Act of 1875 theoretically helped local authorities to rein in the worst offending factory owners, which was advantageous, as by this time the growth of housing and the development of suburbs fuelled a fresh wave of opposition from new householders.

Basford's late nineteenth-century emergence as a Potteries suburb coincided with an increase in complaints about industrial pollution in the vicinity of Basford Bank. The 'smoke nuisance at Basford' was thoroughly discussed in the local press in 1881, following a

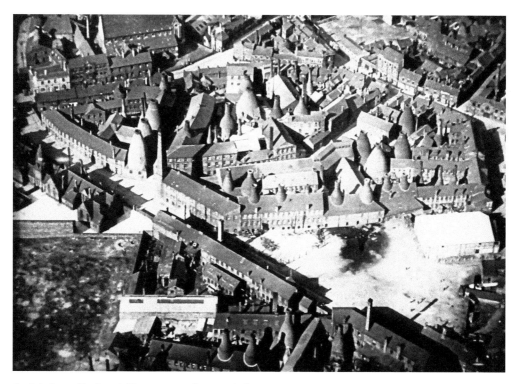

Aerial view of industrial Longton, early twentieth century.

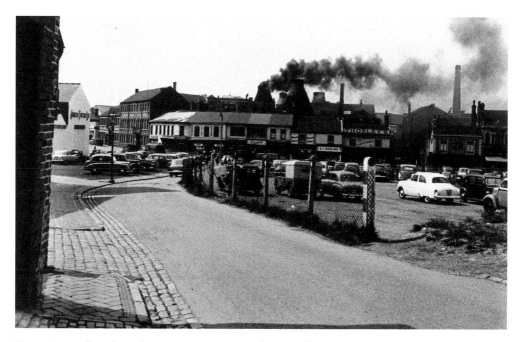

Bus station and smoking chimneys in Longton, mid-twentieth century.

government inquiry in respect of the Public Health Act, and Stoke Town Council's failure to reduce the smoke pollution generated by local brick and tile manufacturers. A Mr Ashmall, representing local residents, said that Basford contained a large number of superior houses that were being made dirty by the smoke that was drifting up the hill from the factories. It was also unhealthy to human life and vegetation. The debate rumbled on for some months, with suggestions being made that tall chimneys might be constructed to better dissipate the smoke. The manufacturers, of course, pointed out that it was impossible to make blue bricks without smoke, even if measures were introduced for smoke abatement.

Other industrialists continued to fall foul of the Public Health Act, with many of their chimneys being monitored for the minutes in an hour that they emitted black smoke. Among those businesses challenged in the 1880s were the Old Hall Earthenware Co. in Hanley and Deep Pit Colliery, owned by Lord Granville, whose engine chimneys were heavy polluters. Mr Lucas, manager of the colliery, pleaded to the courts in 1885 that Lord Granville had spent more than £1,000 in five years in trying to prevent the emissions of black smoke.

With discussions about smoke pollution set to endure for years, Hanley's civic grandees decided to establish the green oasis that was Hanley Park – its landscape architect, the renowned Thomas Mawson, describing the numerous nearby kilns 'belching forth fumes and smoke' with which he had to contend.

Health problems concerning smoke and soot had other implications. Take the plight of the climbing boys – those poor souls whose job it was to climb the chimneys of private homes and to remove soot from them. Historian Steve Booth has written an illuminating booklet entitled *Chimney Sweeps' Climbing Boys (1788–1875) with Particular Reference to Staffordshire*, and I have supplied Steve with further information for his files. However, few other authors have explored the topic, so it is a subject worthy of *Secret Stoke-on-Trent*.

As Steve mentions, a law was passed in 1875 that compelled master chimney sweeps to operate under a licence granted annually by the police, eradicating the use of climbing boys. Chimney-sweeping machines were available to the sweeps, but in many cases were not used – partly because of the expense, and partly because of the belief of some rich householders that the use of machines was more likely to scatter soot upon their precious furniture than the boys were. In order to clear the soot from the chimneys, the boys endured a variety of health problems including spinal deformity, eye problems and several cancers – to say nothing of the occupational hazards.

The Hanley and Shelton Chimney Sweeping Association was established in 1855 in order to apply then existing laws in relation to climbing boys and to promote the use of chimney sweeping machines and to expose and put out of business any master sweeps employing the boys. It is essential to mention some of this movement's leading lights. They include the chairman, Francis Wedgwood, the grandson of the great Josiah, Godfrey Wedgwood (Francis' son), Henry Pidduck, the watchmaker and jeweller, and Thomas Allbut, the printer and publisher.

These gentlemen fought a noble cause that attempted to eradicate horrendous cruelties. There are references in the local press to some boys being too frightened to ascend some of the complex chimney structures of some homes, and being forced to climb and clean higher on account of their masters having lit fires in the grates below them. Many of the boys were scorched by the heat or worse.

Hanley and the Deep Pit, early twentieth century.

A green oasis: Hanley Park, 2012.

Chimney museum, Longport, 2000.

The aforementioned association's inspector, Peter Hall, reported in 1859 that

There are now only three boys employed by sweeps in the Pottery district, and of those the youngest is sixteen, an age when they cannot be sent up chimneys. Machines are universally adopted, and are found to answer in every respect. Builders are carrying out the requirements of the Act as to the size of flues and chimneys in their constructions.

However, vigilance was required for the association's progress to continue in the neighbourhood, for as late as the early 1870s there were still isolated incidents involving the use of climbing boys. In 1870, Herbert Tunnicliffe, a Fenton-based chimney sweep, was found guilty by Newcastle Borough magistrates for permitting a nine-year-old boy to climb a chimney for the purpose of cleaning it. The householder was also charged. It was found that the boy had experienced some difficulty in getting down from the chimney.

The Act of 1875 was championed by the Earl of Shaftesbury but the tireless efforts of Francis Wedgwood and his peers contributed much to the removal of a terrible abuse.

Local Government and Public Services

Did You Know?

Our fire brigades have an interesting history – though some dangerous incidents emphasise the recklessness of some members of the public. In 1843, two young men appeared in court for having thrown fireballs at the end of Burslem wakes, seriously burning a bystander's arm. They claimed it had previously been a wake's tradition. A fire in an outbuilding of the Noah's Ark pub in Hartshill in 1856 illustrated the difficulty that brigades often encountered in accessing the water supply. Engines from Etruria, Stoke and Newcastle rushed to the scene:

> The Newcastle police fire hose and piping was taken up with the engine, but would not fit on the water companies main, so that the firemen had to form a chain of communication with the engines, and pump the water out of the first into the second and out of the second into the third, from whence it was pumped on the burning building.

Somehow, the fire was extinguished!

Local policemen have witnessed some very silly behaviour over the years – as did Police Sergeant Onions in 1870. The drunken Samuel Cronlan had climbed to the top of a street lamp in St John's Square, Burslem, at 2 a.m., and – while 15 feet above the ground – had damaged and opened up the door of the lamp. The reason? He wanted to light his pipe.

The subject of local government is one with which not everyone chooses to engage in Stoke-on-Trent. The Potteries public has long been derided by the self-styled and often self-appointed intelligentsia as being disinterested in regard to politics – hence the subject of 'voter apathy' is often discussed in the local media. However, this hasn't always been the case, even if it's the case now.

Electors in the southern part of the Six Towns were evidently a vigorous lot. In July 1837, there were riots in Lane End following the defeat of two Liberal candidates in the town. A bludgeon-brandishing mob broke the windows of the houses of the successful candidates, also attacking the local police office. The violence raged until the wee small hours, and with the local authorities seemingly powerless to stop it, the magistrates summoned the Staffordshire Yeomanry Cavalry. Arriving in Longton, the horse-mounted cavalry was met

by a hail of stones thrown by the mob, who, showing no respect for the dead, had made camp in the local churchyard. The rioters eventually scattered, and the ring leaders were rounded up and brought to justice. At the time of the 1837 elections, political tensions ran high. A notice was inserted in the local press that nowadays we would think of as bizarre. It began, 'Wanted, in a populous Market Town, in the Northern Division of Staffordshire – Six Conservative Barbers.' The notice went on to state that these barbers should be skilful hairdressers and expert shavers. It was emphasised that many Conservative electors, having become unsettled by the violence that had attended the election run-up, wouldn't trust radical barbers to shave their heads. So 'persons of Conservative principles' were invited to come forward and set up shop as barbers, 'when they may depend upon receiving the support of a numerous body of respectable and influential persons'.

Proceedings at Tunstall in 1874 descended into downright farce, on the occasion of polling day for the election of Parliamentary representatives of Stoke-upon-Trent. On the day of the election, around 3,000 people gathered in Market Place (now Tower Square). Several ruffians sacked a fish stall, and began pelting each other with fish and fish's heads. This escalated into the throwing of old shoes and then stones and dangerous missiles. With a riot imminent, police superintendent Baker and his officers charged the mob, but were pelted with stones. Some officers were injured and others assaulted. The rioters were subsequently taken to court, some being sent to prison and others fined.

It's ironic that alleged voter apathy should be an issue in Stoke, when you consider the plethora of civic buildings – a throwback to those pre-Federation days when each local centre was intent on establishing its own local government and public services.

Tower Square (formerly Market Square), Tunstall, 2010.

Longton Town Hall, *c.* 1927.

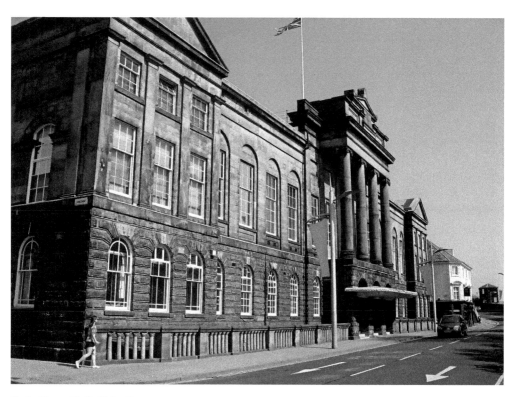

Stoke Town Hall, Glebe Street, 2013.

Most town halls were multifunctional, even embracing concerts and other entertainments. However, one of their key functions was that of a town lock-up. Burslem Town Hall in 1842 witnessed a near tragedy, when Edward Harrison of Newcastle had been confined in the town hall's lock-up while drunk. Shortly afterwards, he was found suspended by a cord around his neck. He was immediately cut down and attended to by surgeon Goddard. However, he received no sympathy from stipendiary magistrate Thomas Bailey Rose when his case was eventually heard by the court. He was reprimanded for his rash act, and told that he 'had no right to take away that which he had no power to restore'.

Incidentally, though none of our remaining town hall buildings compare with the majesty of similar structures in Manchester and Birmingham, they have not gone unappreciated by outsiders. Fenton Town Hall is a case in point. When the Victorian Society compiled its list of the top ten most endangered Victorian and Edwardian buildings in England and Wales in 2013, Fenton Town Hall was awarded fifth position.

The problem has sometimes been that people from within the city haven't appreciated the architectural legacy of the Victorians. It may come as a surprise to some that a vocal minority wanted Burslem's town hall demolished, around half-a-century ago. In 1960, at a time when the Civic Trust had laid out the new gardens area in the town centre, there were rumours that the town hall might be replaced by a 'multiple store'. The Sentinel newspaper reported on the mixed feelings about the building as viewed by the Burslem Chamber of Trade. In 1972, The Sentinel again questioned whether its support from heritage and architecture buffs should guarantee its retention, or whether Burslem's future lay in the removal of a building seen by some as 'black, filthy and useless' in favour of a 'modern retail paradise'. Stanley Bourne, a member of the City Council General Purposes Committee, even declared at the time that the hall was a depressing building and a 'monstrosity' only deserving of demolition. He advocated its replacement by a supermarket. Burslem's town hall of 1857 is today a Grade II listed building – a reminder of local government, before the Federation of the Six Towns, an adornment to the town and soon to undergo new use as a new sixth form centre.

Though the role of a town crier is now largely ceremonial, it was once an important post in the days when newspapers were scarce and literacy standards were low. However, like any other servant of a local authority, the town crier was not always beyond criticism from the public. In 1846, John Taylor (1769–1857), Hanley's crier, proceeded, according to the orders he had been given, to proclaim the loss of a child belonging to a Mary Leighton. When he was only halfway through his task, he was violently assaulted by the aforementioned Mary – it having been the case that the child had been found almost immediately after John's first tinkle. Unfortunately, John's duty required him to repeat his announcement a number of times after his first proclamation, and as he did this, Mary 'administered no slight chastisement on the persevering bellman'. She was suitably punished by the courts.

Incidentally, The Sentinel reported in 1995 that Elizabeth Barnett, of Kidsgrove, had died at the age of ninety and was being mourned by five generations of her family. She was the daughter of Jacob Bird, the last town crier of Tunstall.

The road to efficient law enforcement in the Potteries was a tortuous one, though a public meeting at Hanley in 1817 convened by the majority of the head constables of Burslem, Hanley, Shelton, Stoke, Fenton and Lane End at least served notice of an intention to establish credible peacekeeping. The appointment of a Potteries stipendiary magistrate in 1839 and the

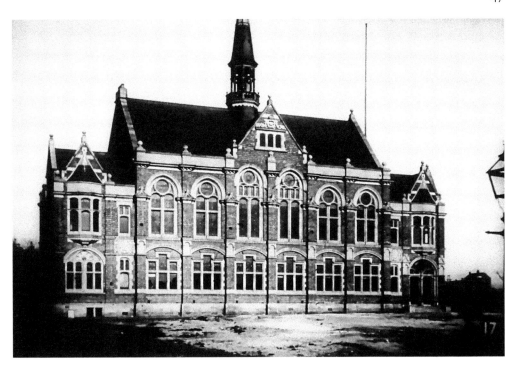

Fenton Town Hall.

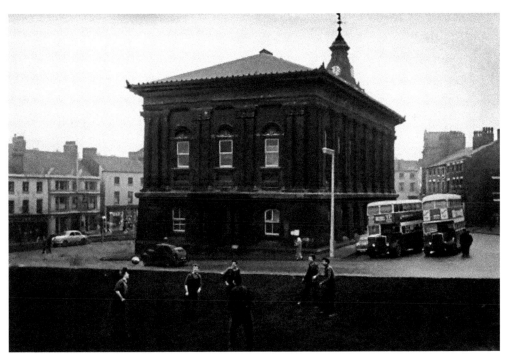

Burslem Town Hall, with Civic Gardens being constructed, *c.* 1960.

inauguration of the Staffordshire County police force in 1842 were further milestones on the journey that spanned the period from amateur unpaid constables to paper-pushers in patrol cars.

It will be seen that public servants such as the town criers, watchmen and police constables of the town were all vulnerable to attack from an unpredictable society. The police court reports in our local newspapers are a treasure trove of information, highlighting the types of crime that were being committed, the social class of offenders and their reasons for straying from the moral path.

Some transgressors regularly appeared in the reports, no doubt bringing a wry smile to the readers of our local newspapers – especially as their aliases were often mentioned. In 1837, Thomas Pope, a well-known character in Hanley, found himself up before the courts for repeated bad behaviour. People reading the *Staffordshire Advertiser* would probably have grinned at the mention of his nickname, Tom Quack. The prostitute Hannah Bolton is mentioned in a report of 1873 for being drunk and riotous. Hannah's alias was The Flying Scud.

The long arm of the law routinely dealt with social nuisances like Hannah, but large mobs were a different challenge altogether – especially when they took place in the middle of Stoke-on-Trent's largest town. Crown Bank, Hanley, was all too regularly the scene of public disorder, no doubt partly due to the number of public houses nearby. Thomas Roberts and George Astbury began a fight at this place in 1859, which swiftly drew an audience of 200 people. Pity the poor policemen who had to deal with a row outside a grocer's shop in Smallthorne in 1869. It raged for around ninety minutes and attracted nearly 1,000 people.

At various times, some local areas gained a reputation for bad behaviour, and Hanley was one. Bemoaning the inadequate police arrangements in the Potteries in 1846, the *Staffordshire Mercury* – which was published in Hanley – drew attention to the town's social problems:

> The riotous noises in the streets at night – the beastly scenes of intoxication throughout the Sabbath – the constant and systematic obstruction of the public footpaths by gangs of insolent idlers – the wanton destruction of property – the number of undetected robberies – all tend to show that instead of improving upon the old and exploded system of parish constables the conservators of the peace have retrograded.

Disruptive behaviour tarnished the reputation of other locations, too. Following a murder involving firearms in Brown Edge in 1875, the *Staffordshire Times* reported that,

> A free fight a Brownedge is by no means a rarity, for unfortunately, the residents in this neighbourhood are of the rough Staffordshire Moorlander class, gangs of young Brownedgers, being the terror of the Pottery publicans and police, as the records of most of the county police courts will disclose...

Tunstall's town museum was said to have been decidedly short of artefacts of genuine interest to Victorian visitors. The *Local Herald* suggested in 1900 that one connecting link with bygone law and order might be conveyed to the museum as a much-needed item of curiosity:

The old iron stocks ... lying in the police yard exposed to the weather and fast rusting away, might, and ought to be preserved, with the many interesting incidents connected. Many another relic also may doubtless be found, any, and all of which add interest to the museum.

By this time, the stocks in many towns had been consigned to history, but there would still have been people living in 1900 who recalled the days when miscreants were punished for their crimes by a spell in the stocks. Unfortunately, such a punishment was itself often productive of disorder. Take an incident in Burslem, in 1834, commented upon by a correspondent to the *North Staffordshire Mercury*. He reported that two men had been placed in the stocks by the town authorities for drunkenness, creating much interest from a large crowd of raucous rubberneckers. Such scenes were not unusual, but this happened to be a Sunday, and local people passing to and from their various places of worship were said to be annoyed by the scenes.

Another annoyance was fire, which had considerable destructive potential during the early days of firefighting in the Potteries. Before Federation in 1910, each of the Six Towns had its own volunteer fire brigade, operating largely separately – although when bigger fires occurred, several local fire engines often rushed to help. They might come from neighbouring towns, and even nearby pottery factories. Messrs Copelands of Stoke had one, as did the Wedgwood factory in Etruria. However, primitive equipment combined with an unreliable water supply meant that every fire posed a serious problem. In addition, the volunteer fire brigades didn't always keep their engines in good condition.

Burslem Fire Station, 1959.

In 1844, shortly after Enoch Wood's pottery works had survived a fire, Burslem's commissioners of police were able to secure a new, first-class, Merryweather fire engine. They were delighted that it could throw 'between 6 and 7 cwt of water in a minute' and could shoot water to the extent of 105 feet. Yet only four years later, in 1848, a resident of Burslem felt compelled to complain in the *Staffordshire Mercury* about the 'total want of a fire brigade' in the town, and the disgraceful condition of the engine. The volunteer fire brigade, he averred, had all resigned, and the town had been left with a rusting engine and its mouldy hose.

The years 1925–26 saw the end of the volunteer fire brigades and the creation of the City of Stoke-on-Trent fire brigade, whose professional staff were commanded by Chief Fire Officer Carter. With firefighting arrangements now well and truly in apple pie order, it was only necessary for local rivalries be taken into account.

However, in 1928, feathers were ruffled outside the city, in neighbouring Newcastle-under-Lyme. A fire in Basford Park Road, within the borough boundaries, was attended by the city fire brigade, who chose not to pass on the call to the Wolstanton brigade. Three of the city's engines dealt with the blaze for an hour, and only then were Wolstanton's brigade contacted. Quite clearly, they took umbrage. It was decided to report this intervention to the city authorities, the city official responsible having – it was claimed – 'acted in a high-handed manner'. Sometimes, you can't do right for doing wrong.

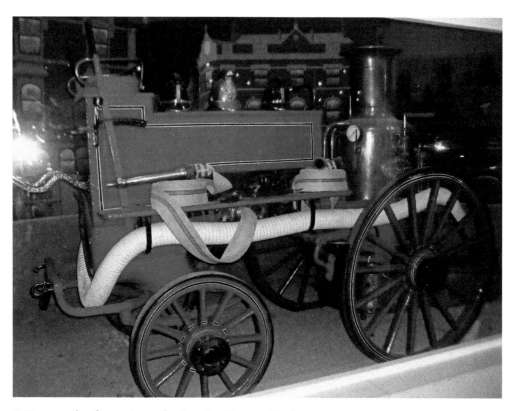

A Merryweather fire engine in the Potteries Museum, Hanley, 2015.

Shops

Long before the modern supermarket sashayed into town, Potteries people would buy food and household items from smaller shops and markets – both indoor and outdoor. Indoor markets today offer a vibrant, hands-on shopping experience as well as genuinely friendly customer service from assistants undamaged by staff training and formal qualifications. However, all of us who enjoy this rough-around-the-edges shopping experience should be aware that it had its downside.

With cholera having taken so many lives in 1832, health issues were being considered more carefully than before. The butcher's market in Hanley – now housing a Wetherspoon's pub and a Waterstone's bookshop – had only opened the previous year, but a complaint was made to the local press about it selling meat that was unfit for human consumption in the evenings, when there was less daylight to expose the poor condition of the meat. The newspaper correspondent urged the market inspector and the Board of Health to look into the matter. In a postscript, the reader updated his story: on the previous Sunday, he claimed a pig had died from the effects of disease in Hanley. Three days later, its meat was sold in the market by a butcher, 'whose name, Mr Editor, you may become acquainted with if you wish'. It was no solitary case, asseverated the reader. A similar case was found in Longton in 1886, when Mr John Shenton, a butcher, was charged with selling unfit beef. The market inspector had found a piece on Shenton's stall in Longton market that was 'black, sticky, ill-fed, and unfit for human food. In a basket close by witness found half-a-dozen smaller pieces of beef of a similar character'. A medical

officer confirmed that it was probably diseased and unfit for consumption. Such crimes were a serious threat to health; but if food was off, at least you could throw it at people. A notorious individual named Samuel Challinor was, in 1866, charged by the Longton market inspector with pelting people in the market with rotten oranges.

The link between livestock markets and the high streets is seen in the establishment of a number of butchers' shops in the Potteries. The accompanying photographs were supplied by a correspondent, Laurence Davidson – a descendent of a well-known family of Hanley pork butchers. W. S. Brown and Sons had a slaughterhouse just off Broad Street. Laurence informs me that William Southall Brown lived from 1848 until 22 June 1909 and that family photographs were once displayed in the still-extant Old Plough in Etruria Road, Hanley. W. S. Brown had been a member of the North Staffordshire Butchers' and Cattle Dealers' Association. He was buried in Hanley Borough Cemetery.

The Sunday Trading Act of 1994 allowed shops in England and Wales to trade on Sunday, it having been the case that buying and selling had previously been illegal, with exceptions, as stated in the Shops Act of 1950. However, its illegality did not mean that rules weren't broken, and today's debate about the rights and wrongs of Sunday trading is only an echo of a discussion that was raging in Hanley as far back as 1879.

Alderman Gilman told the Hanley Watch Committee that as the country had decided that one of the seven days should be given up to rest, it was a discredit to Hanley that shops were being kept open on the Sabbath. Various speakers cited seven or eight shops open between

Above left: Askey's fish shop, Burslem, date unknown.

Above right: Indoor market, Burslem, 1973.

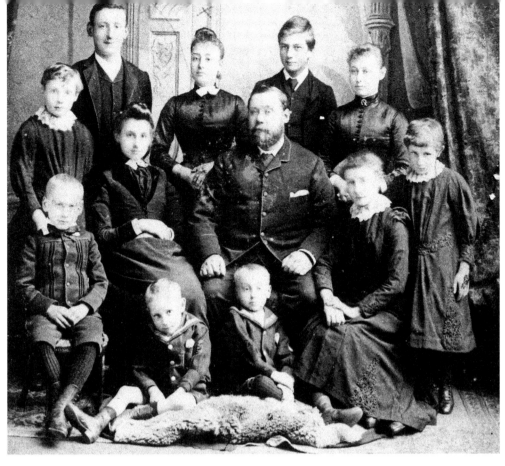

Above: W. S. Brown and family, 1888.

Below and overleaf: Brown's pigs being led to slaughter, Hanley, early twentieth century.

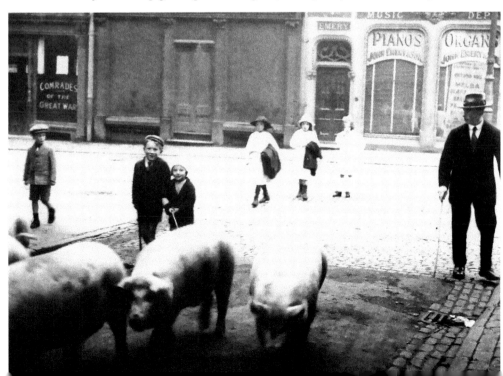

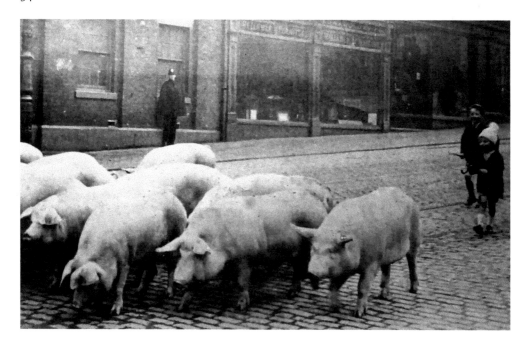

Piccadilly and Shelton church and almost every shop premises leading from High Street to Far Green (now Northwood) and in Marsh Street. However, there was a counter-argument. It was said that the beerhouses adjacent to the offending tobacconists' shops were selling tobacco on a Sunday with impunity and without authorisation – so why couldn't a shopkeeper do likewise? It was agreed that the town's chief constable be instructed to caution vendors of non-perishable goods against opening their shops on a Sunday, as they were breaking the law. It was not until 100 years later that the larger chains became powerful enough to virtually rewrite the law, and Sunday trading is now with us for good.

From the late nineteenth century, some of the greatest retail names in Hanley were beginning to lay down roots, though it is interesting to note that draper Oliver Dyke (1860–1924), upon arriving in the Potteries in 1890 – he was ultimately to go into partnership with Ralph Bratt – was told by a business friend that 'Not only was the business proposed to be taken over itself wanting in public confidence, but the town was about the last place on the face of the earth for a pushing man of trade.'

However, Hanley's centrality and its fast-increasing population helped Dyke to prove his friend wrong.

In the past, as now, the larger companies employed all manner of gimmicks in order to magnetise the public. Dyke once organised a 'mile of pennies' in support of the Mayor's Charities Committee. The pennies stretched around the whole of the frontage of Bratt and Dyke's store in Stafford Street and Trinity Street and persuaded other nearby traders to emulate his effort.

Messrs Huntbach and Co. Ltd held an annual mannequin parade on its first floor, with staff members parading in the latest fashions. Perhaps those people who bought the swish

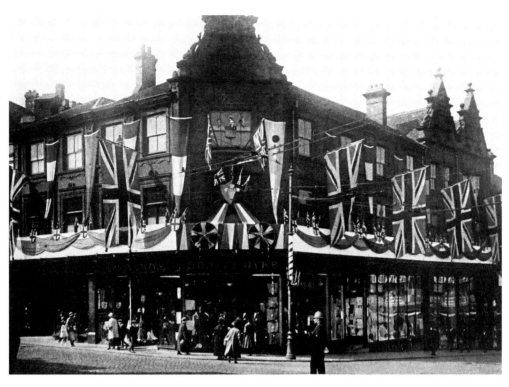

Bratt and Dyke shop, Hanley, 1950s.

Shops in Brickhouse Street, Burslem, 1991.

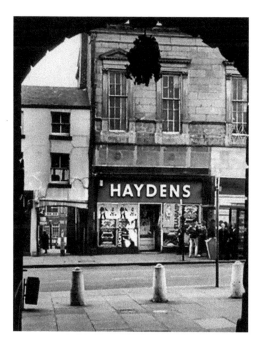

Haydens, Market Place, Burslem, 1991.

new clothes then required a healthier look. Fortunately, Huntbach's could oblige, for it advertised in 1927,

> the installation of an ultra violet ray lamp in a room on the second floor. Ultra violet ray treatment has come to the fore very rapidly in recent years, and great benefits have resulted from the treatment. Within the space of a two and a half minute exposure to the violet rays, the most pasty, after-influenza-looking complexion is transformed into a healthy tan such as might be expected after a month on the Riviera.

Extant photographs of the old Huntbach's store testify to its magnificent height. However, in 1943, city centre shoppers witnessed a terrible tragedy when one employee fell 60 feet through a fourth-floor window to her death. Mary Cholerton, forty-five, a laundress, was in the habit of looking out of the window, and apparently became dizzy, having complained of giddiness and headaches for the previous five months. The window overlooked Swan Passage, and was said to have had a fairly low sill. Mary was in the habit of looking out of the window at the clock on the tower of St John's church, and on this occasion had toppled to her death.

Another major store in Hanley was McIlroy's, the later Lewis', and they too employed bold advertising methods – especially when the store celebrated its forty-fifth birthday in 1928. A well-known pilot, D. Van Gessel, was recruited to fly his aeroplane over the premises on 29–30 May, between 2.30 p.m. and 3.30 p.m. each day. Observers were encouraged to enter a competition by guessing the altitude of the aircraft.

Many famous and not-so-famous names enjoyed great longevity in the Potteries. Almost nobody living in Goldenhill today would remember the name of Samuel Whittaker, who was the village's oldest tradesman at the time of his retirement, announced in the local

press of 1932. He was seventy-five years old and had traded in Goldenhill for thirty-eight years. A more famous name was Williamson's, the jewellers and photographers in Stafford Street, Longton. The shop closed in December, 2014 after a century of trading. Its value to the community over the years came to be recognised long ago, and in this sense, it shouldn't rate a mention in *Secret Stoke-on-Trent*. However, the accompanying behind-the-scenes photographs of this warren of an emporium are not out of place in a book of this nature.

Another long-lived Potteries jeweller, Pidduck's, had first set up shop in Hanley in 1841. An emporium of this nature was naturally an occasional target for opportunist thieves. In 1938, a man walked into the shop and asked to be shown some engagement rings, as he was going to be married. Telling the shop assistant, Mr Stubbings, that money was no object, he was shown a tray of rings with a total value of £2,000. When the assistant was distracted, the man ran off with the tray towards a black Chrysler car that had its engine running, just outside. The thief jumped into the car, which immediately sped off, but not before Stubbings – a middle-aged man – had grabbed the passenger door handle while the car was moving. The car, which had been waiting with its clutch out in order to hasten its getaway, lurched forward, with the plucky assistant falling to the ground. On Crown Bank, the car swung around the corner and into Piccadilly – in full view of numerous shoppers – and then whizzed off towards Stoke. A bus conductor on a bus travelling up Piccadilly, said that he was forced back by the draught from the car as it sped past at around 60 mph. Meanwhile, the driver of the bus had to pull on to the footpath to avoid an accident. The thieves' car almost hit two cars at the junction of Pall Mall and Piccadilly. I've yet to trace what became of this case, but it wasn't the last time that Pidduck's was the scene of a daring robbery.

In May, 1957, smash-and-grab raiders hurled a block of cement through their window and audaciously seized a pad of twenty-five diamond rings before making off by car down Piccadilly at high speed. The black saloon getaway car, reaching speeds of nearly 50 mph, was pursued for nearly a mile to a point beyond Howard Place by a Hanley accountant, Edwin Downward, in his grey Humber. Edwin later told the local press that the thieves' car nearly bumped into some parked cars near Hanley Garage, but managed to swerve around them. At Howard Place, the getaway car swung around the wrong side of a roundabout and into Shelton New Road. He had to break sharply to avoid colliding with a bus coming up from Stoke, and afterwards lost them. This was truly a case of daylight robbery, as the raid took place at 10.40 a.m., by which time Market Square was very busy with shoppers. This case was recalled in *The Sentinel* in 2013 by Tom Parton, who was a scenes of crime officer for the police at the time. Tom remembered that the thieves were brothers from London. They were eventually caught, and received hefty prison sentences. What had been a carefully planned crime – involving false number plates on their getaway vehicle – had been foiled. The older brother, upon going to prison, told Tom, 'You're not so thick up north, after all.'

Shops and their architecture have changed radically since Williamson's was built. The Potteries Shopping Centre in Hanley – now Intu Potteries – didn't impress everyone when first built. Conservative Councillor for Trentham, Ian Parry, described it as a 'glitzy retail Tardis' that was responsible for twenty empty stores in prime city centre sites, and the neglect of areas such as the East Precinct. The PSC may possibly have opened earlier than it did – 1 June 1988 – were it not for a building delay mentioned by George Heeks of Alsager, in *The Sentinel* in 2011. George was site manager for Shepherd Construction of Manchester, who were responsible for the brickwork. He revealed, 'One area near Lewis's was declared off limits until a pair of blackbirds had raised their young.'

Williamson's, Longton, 2014.

Williamson's, Longton, 2014.

Williamson's, Longton, 2014.

Williamson's, Longton, 2014.

Education

Religion played a huge part in the growth of education in the eighteenth and nineteenth centuries. The road towards a state education system and the Education Act of 1870 was long and tortuous, presenting many challenges to those who wished to instruct and enlighten the masses.

Even from 1870, discussions in regard to the respective merits of state schools and denominational schools were often intense. The Education Act's insistence that 'No religious catechism or religious formulary, which is distinctive of any particular denomination shall be taught in the school' was a robust attempt to reset the compass of education. It didn't sit well with some religious figures, with the Revd Lovelace Stamer, rector of Stoke, at the opening of the new National School in Wolstanton in 1872, believed that 'there was a general deep-rooted affection for the Church of England' and he considered that they of the Church only aimed at strengthening its influence by the provision of more schools.

The push for secular education without the religious element had been advocated long before 1870. One of the most turbulent episodes in Burslem's varied religious history

Above: The former Broom Street Board School, Broom Street, Hanley, 2014.

Below: Swan Bank Methodist Church, Burslem, 1970.

occurred in the 1830s, and is mentioned by the historian John Ward, writing *c.* 1840. However, for a better flavour of the frayed tempers and righteous anger that raged at the time, we must consult the newspapers of the day. They give a graphic account of the ideological rumpus that took place at the Burslem Sunday School of the Wesleyan Methodist chapel at Swan Bank.

Some early nineteenth-century teachers did not agree with the preachers of the chapels they served. When those at Swan Bank were told that they couldn't teach writing or arithmetic on the Sabbath, they took umbrage. The teachers were more receptive to new social and political ideas than their religious associates, and a dispute between traditionalists and modernisers was the result. The trustees of the Wesleyan Methodist chapel inserted a notice in the 14 May 1836 issue of the *North Staffordshire Mercury*, informing the public that its schoolrooms had been closed on account of the teachers and managers, who, it was claimed, were 'in a state of hostility towards Methodism, and are seeking its subversion'. The notice further stated that the school would shortly be reopened, but only to those children whose parents were supporters of Wesleyan Methodism.

However, the teachers and managers were not about to take this lying down, especially as many of them had served the school loyally for between ten and thirty plus years. They denied any subversion, merely wanting, they claimed, to inculcate 'the principles of our common Christianity, without reference to the peculiarities of sect or party'. The teachers were certainly not prepared to be vilified by the Wesleyan Methodists, and openly solicited the support of the wider public. This war of words was played out in the local press, the teachers expressing that their characters had been slanderously abused.

Feelings were running high in Burslem at this time, and on the night of 11 May, several windows in the Wesleyan chapel were broken. In addition, several large stones were thrown at the windows and door of the house belonging to the Revd Scurrah, the church minister. The splinter group met in temporary premises, before raising the funds to open their own Sunday school – separate from the Wesleyan School – in Liverpool Road (now Westport Road), Burslem, in 1837. It was far from finished at that stage.

Its foundation stone had been fitted with a brass plate, rather pointedly conveying that the school would be 'for the education of children of all denominations'. The opening of this monumental new institution might well be seen as a victory for democracy and free-thinking. Around 7,000 people attended the foundation stone laying, emphasising the success of the breakaway group in arousing public support. Bear in mind also that it was erected during one of the most economically depressed years of the nineteenth century – this because many poorer people believed in the school's aims and were prepared to dig deep to support the project. When we read of the lists of subscribers to new church and civic institutions that were routinely published in the nineteenth-century press, we note the names of the great and good: the manufacturers, colliery proprietors and captains of industry, who could afford to donate large sums of money. However, many working-class supporters contributed to the new school's establishment through voluntary donations. Their support was crucial, and it is relevant to quote this extract from the *North Staffordshire Mercury*:

At the opening services of the Burslem Sunday School, on Sunday week, a poor woman in but humble attire, was observed by one of the persons in care of the plates, to put in

half a sovereign. Supposing she had made a mistake, he called her back, and asked her if she knew what she had given. She replied that it was no mistake, but a cheerful offering to the cause, observing it was true she had been some time in 'getting it together' but they were heartily welcome to it ... The rich man's guinea is an inconsiderable portion of his surplus gold; the poor man's donation is often, like the above instance, an accumulation of offerings privately set apart amidst a hundred little wants ...

A retrospective view of this very public internal squabble of the mid-1830s is included in *Hill Top Centenary* (Watts and Brown, 1937). The Burslem Wesleyan trustees, expressed the authors, were merely seeking to apply rules that were not devised by them, but by the connexional authorities on all the schools in the country that met on Methodist premises: 'The superintendent would have had to answer to Conference if he failed to enforce them.' The conciliatory tone of the authors and their desire to apply calm reflection to this tense episode in Methodism's history is further underlined by the declaration that all past bitterness had faded by 1937 and that the Hill Top Methodist Chapel and Sunday School supporters viewed the Swan Bank Methodists as friends and neighbours.

Not far from Burslem, it was possible – if your luck was really out – to receive education in an altogether different type of institution. The whole ethos of the new 'deterrent' workhouses that were introduced, post-1834, was that these buildings did not offer refuge for those people who had fallen on hard times. Instead, they were to be a grim reminder of what lay ahead for those who would seek parish support – effectively, a punishment that would teach them a lesson for their failure in having to seek relief in the first place. Schoolroom

Portico of the former Hill Top Methodist Chapel and Sunday School, Westport Road, Burslem, 1994.

lessons were nevertheless provided for the education of inmates, and local workhouses often advertised for suitable candidates for the post of schoolmaster. George Goodwin is listed in the 1841 census as the fifty-year-old schoolmaster of the Wolstanton and Burslem Union Workhouse at Chell. He is mentioned in a newspaper report of 1840, which reminds us that it's no wonder that inmates tried to escape from the brutality of Chell Workhouse.

A magistrates' court case was brought against a mother whose child had been cruelly treated. Schoolmaster Goodwin was evidently a ruthless individual. A mother, who was also an inmate, had heard from a third party about Goodwin's brutal attempts to discipline her four-year-old boy. She saw that there were marks across this child's face where he had been struck by the schoolmaster. The court later heard that she'd gathered that Goodwin was in the habit of beating young boys with bunches of keys or a thick knob stick – sometimes across the head, so that they were left with lumps on their heads. The mother attacked the schoolmaster in retaliation, kicking him, striking him on the head and aiming a blow to the ear. Unfortunately for her, the matter ended up in court. The magistrate's verdict tells us much about the times. The case brought against the mother was dismissed, but in summing up, Thomas Bailey Rose declared that he didn't approve of this way of punishing children ... he thought that the birch was the best instrument!

In the aforementioned case involving Goodwin, there is no hint in the workhouse Guardians' Minute Books that they felt any contrition in respect of the matter:

> The attention of the meeting was called by the clerk to the assault made by one of the female inmates upon the schoolmaster for beating her child. The case had been brought before the Stipendiary Magistrate and dismissed by him. The Board considered that the charge was proved and that the authority of the schoolmaster should be maintained (in the proper discharge of his duty) the above decision having a contrary effect. The schoolmaster was directed to use only proper weapons in correcting the lads, and to report in case any should be refractory.

Another example of a workhouse schoolmaster bringing his profession into disrepute occurs in 1884. The Local Government Board heard that Thomas Unwin, the Stoke Workhouse schoolmaster had taken around fifty boys out for their 'annual exercise in the country' but that he had led them to Newcastle, where he had left them in the street without any supervision for nearly two hours while he drank in a public house. Mr Jones, the assistant master of the workhouse, testified that upon Unwin's return, he was walking 200 yards behind the children and was apparently drunk. Other witness' evidence during the cross-examination gave slightly different accounts of what had occurred, though two of the boys submitted that he had left them for twenty minutes outside a barber's shop, then minutes outside a fish shop, and around an hour and five minutes outside the pub. While he had been in the pub, the boys had been very disorderly in the street.

Self-education and the meetings of enlightened minds were often the preserve of the affluent. Those who wished to better themselves through debate and the exchange of ideas and information had ample chance of doing so as long as they could pay for it.

The Socratic School in the town of Stoke was set up in 1830, formally governed by a president, secretary, librarian and fellows, its aim being to 'encourage virtue and discourage

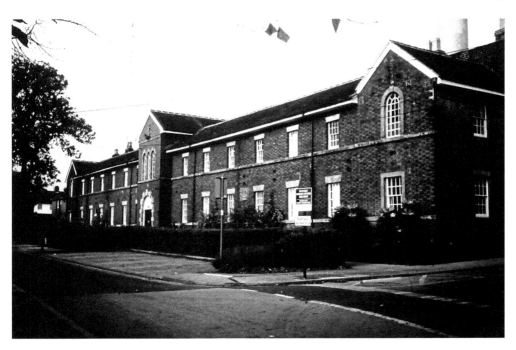

Façade of former Stoke Workhouse, 1996.

vice' through the promotion of lectures and publications. Members met to discuss literary, philosophical and useful subjects and launched a circulating library. The civilising tendency of the society prompted it to offer 'pecuniary and honorary rewards for correct principle, good conduct and long service'. Annual membership was 10s 6d per annum, while those who subscribed £20 could be life members, suggesting that members were probably drawn from the ranks of better-off tradesmen. At a meeting of the society in 1831, at the Wheatsheaf Hotel in Stoke, there was a pre-dinner lecture delivered by the chairman on the question of 'What was the age of the old Parish Church at Stoke-upon-Trent, Staffordshire and what is the probable period when Christianity was first introduced there?' The society advocated success to the Staffordshire Potteries, the 'liberal professions' and the adoption of pacific principles around the world.

It was one of many similar societies and institutions – usually operated and financed by middle-class patronage – that attempted to disseminate knowledge and a love of enquiry. A similar institution was the Fenton Athenaeum , championed by William Baker IV (1800–65), who became president of the committee that ran the society. It launched a series of public lectures, and like Burslem History Club, the North Staffordshire Historians' Guild and other such societies today, it required an expanding range of speakers. The widely travelled Revd C. P. Wilbraham of Audley addressed numerous societies, and his talk entitled. 'Incidents in the Four Quarters of the Globe' given to the members of Fenton Athenaeum in 1859, was typical of his offerings. The Revd Benjamin Vale, who started the Socratic Society, put his polymathic knowledge to good use elsewhere, presenting a lecture on Pythagorean Arithmetic to Hanley's Pottery Mechanics' Institution in 1844. William Woodall, pottery manufacturer and Burslem MP, was another prolific speaker.

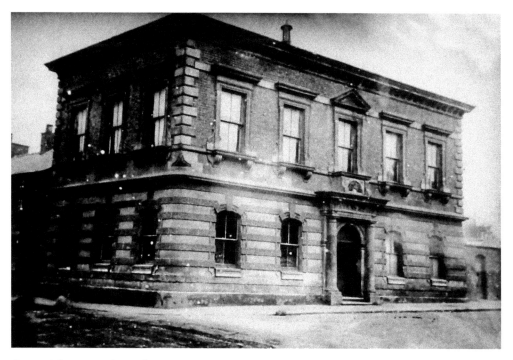

Fenton Athenauem, date unknown.

Cerebral stimulation and thought-provoking philosophy was not everyone's cup of tea, and the offerings of Tunstall Athenaeum were more diverse. It held annual fetes at Porthill Park, near Longport, in the late nineteenth century, and attractions ranged from juvenile choral contests and operatic selections by the Grenadier Guards' Band to Punch and Judy and 'amusing negro comedians'.

Such popular frivolity may not have appealed to the young ladies of the little written about North Staffordshire Association for the Care of Friendless Girls, sometimes known more conveniently as the Girls' Friendly Society. Having been established for a short while, the society opened new premises in Edmund Street, Hanley, in 1882. It was effectively a boarding school, requiring a high standard of character from pupils and declaring that it could not 'help the rougher class of girls. Parents of this class are often too poor to get the outfit of clothes necessary for decent service.' The objective was to give the girls a good start in life and to help them to become respectable wives and mothers. Employment for the girls was arranged by the society and her wages were paid to its office. In this way, board was paid for and a spirit of self-sufficiency encouraged. Girls were given a little pocket money, but much of their wages went to a clothing account, the association operating a sewing class. There, the girls were fitted for the clothing they required. While they sat with needle and cotton, an 'amusing but profitable' book was read out to them and a Bible lesson followed. Girls were also given the benefit of a monthly interview with a matron, who listened to their difficulties and dispensed motherly advice.

There were many other such schools in the Potteries that competed for the support of the better-off. Many children however enjoyed a standard education whose quality improved

Etruria Board Schools, 2001.

with the coming of the board school system in 1870. The girls' section of Chell Board School, built in the mid-1870s, also taught sewing and needlework, like the aforementioned Hanley boarding school. The log books indicate that there was some other common ground between the two establishments: 'Most of the garments made for inspection have been sold to children.' (Log book, 14/10/1879). The log entries embrace many grumbles about parents' reluctance to pay children's 'school pence', lateness, poor attendance, and outbreaks of measles, influenza, etc. More interesting are the entries that tell us something about the outside community. For instance, on 7 February 1881, it was recorded that 'The attendance has been very poor all day especially this afternoon owing to the severe weather and the explosion which occurred this morning in the neighbourhood.' This alludes to the terrible explosion at the nearby Whitfield Colliery that took the lives of twenty-four men and boys. On 14 September 1883, the log stated, 'Four girls left the district. Fathers, being miners on strike, have sought work elsewhere.' We also read (6/7/1894) that attendance had been too poor on Monday afternoon to mark the registers. Burslem Wakes had proved an irresistible counter-attraction to school.

The logbooks of many other schools give many interesting reasons for absence, for example, Hanley Higher Grade Board School (Hanley High School), which opened in its original form in 1894. Among the many reasons for poor attendance, we find the counter-attraction of the Hanley Horse Show (13/5/1897); the visit of Barnum and Bailey's circus to the district (11/11/1898), when the number of pupils present was 43 per cent of those on the books in the morning and 55 per cent in the afternoon; the visit of 'Buffalo Bill' and his Wild West Show to Stoke (25/4/1904); and the epidemic of Spanish influenza in the district (6/7/1918).

Hanley High Schol, date unknown.

Thistley Hough School, Penkhull, during demolition, 2013.

Religious Worship

Religious buildings in Stoke-on-Trent have ranged in size and architectural pretensions from mighty Romanesque Catholic edifices and unfussy Primitive Methodist chapels down to decidedly makeshift places of worship. Among the last mentioned, we may mention the so-called 'tin churches' – such as the one opened at Talke-o'-the-Hill in April, 1868. However, there were more of these humble structures around the Potteries than might be thought.

Such churches were inevitably vulnerable, given that their outer shells were liable to corrode and weaken, and a couple of them met a sorry end. An iron church at Cliff Bank in Stoke, described as 'auxiliary to the parish church [of Stoke]' was destroyed by fire in 1865, notwithstanding the best efforts of the police, the town fire brigade and Mr Copeland's engine. It had evidently been a busy church, as between 160 and 170 scholars attended its day school, and it had only been enlarged the year before. Another iron church, which had been in the course of construction at Boothen in Stoke, was blown down by a severe storm in 1877. This church, had it survived, would have been a 'recycled' one, as it had previously been used as a temporary structure during the rebuilding of St Giles' church in Newcastle (1873–76).

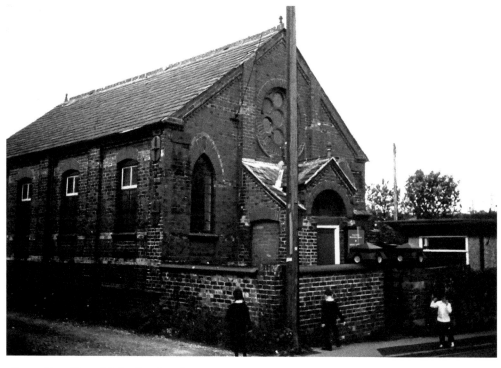

Above: Fegg Hayes Methodist chapel, 2001.

Below left: Christ Church, Fenton, date unknown.

Below right: St James' Church, Longton, date unknown.

Some of these structures enjoyed great longevity. St Matthew's was a mission chapel opened from Holy Trinity, Northwood, in 1899. Located in Leonard Road (later Birches Head Road), Birches Head, it was known by local people as 'the old tin church on the hill,' and was built as a temporary structure. However, it stood long enough for parishioners to celebrate its golden jubilee in 1949, at which time it was stated that building work on a new church might start in the near future. By the following year, there was still no progress and it was stated that more repairs would be needed to keep the old building weatherproof and habitable. It ultimately survived until 1956 and was superseded by a new church in 1958–59.

One 'tin church' survives in Goldenhill: Christ Church, which over the years has been dubbed the Tin Church, the Free Church and the Top Church. It was originally opened in 1874, by a splinter group that had seceded from St John's Anglican Church. Hereby hangs a fascinating tale that is known to relatively few in the Potteries.

Frederick Elmer was the incumbent of St John's between 1858 and 1873, afterwards moving to a new post at Biddulph. During his time at Goldenhill, Elmer had been staunchly anti-Papist, avoiding any Catholic ritual. He was consequently very popular with his congregation, for they too were equally determined to resist all 'popery'. With Elmer's departure, there occurred a spiritual crisis in Goldenhill.

When it became known that Elmer was to be replaced by the Revd Osmond Dobree, who was High Church, there was uproar in Goldenhill. The Low Church congregation and the outgoing incumbent wrote separate letters to Bishop Selwyn opposing Dobree's appointment. Dobree was a chaplain of a private chapel at Knypersley. Like Bishop Selwyn, he was an adherent of the Oxford Movement, which favoured High Church ceremonial. Many people saw Dobree as a highly unsuitable appointment for Goldenhill, but the Bishop stuck to his decision even when Dobree offered to withdraw. There was robust debate in the *Sentinel* newspaper and at public meetings. At one of them, in June, 1873, Elmer read out his protest letter to the Bishop, as well as Selwyn's reply, and the meeting's chairman, Mr Perry, read out similar correspondence. Leading inhabitants announced that they would boycott Dobree's services, and a rash of resignations followed – the school manager (John Henshall Williamson), the entire choir, both churchwardens, the organist and all but one Sunday school teacher. It was decided to build a separate church.

Dobree was installed on 16 September 1873, much to the resentment of locals. A clutch of villagers attended, and an emergency choir had to be brought in from Knypersley. The bishop chided the breakaway group, who conducted a service in a room at J. H. Williamson's Colour Works. The new vicar exacerbated matters by preaching a self-pitying sermon in which he compared himself to St Paul and his sufferings. This drew a withering response from an anonymous *Sentinel* reader as debate continued. One letter writer denounced Dobree as an unchristian and 'seditious' character. Once installed, he duly introduced High Church ritual.

The opening of the breakaway church in Goldenhill saw its officials attacking Dobree for the rupture, with Thomas Jarratt declaring that the congregation existed as a protest against ritualism – he alluded to 'Romish and idolatious ceremonies' – and were not frightened by Dobree's 'big words'. Christ Church in Rodgers Street still stands today and its parishioners were proud to celebrate its 140th anniversary in 2014 – a reminder of the villagers' raging disagreements of yesteryear.

St Matthew's Church, Birches Head, 2015.

Christ Church, Rodgers Street, Goldenhill, 2011.

The fireworks that occurred in Goldenhill say much about local religious fervour, but also of a clergyman's capacity to divide or offend a community. The Potteries has known many colourful and controversial men of the cloth over the years – and not a few notable preachers.

Richard Weaver made a name for himself in the 1860s as a revivalist preacher, billing himself as the Converted Collier, speaking at such venues as the Covered Market in Hanley, and Sneyd Green Primitive Methodist chapel. He was not slow to promote himself. T. Bayley's shop in Newcastle could offer followers a 9-inch 'Parian Bust of the Converted Collier' while specimens of his preaching were also available for sale. Another popular preacher at locations such as Kidsgrove, in the 1870s, was Harvey Teasdale – known as the Converted Clown.

One preacher singularly disgraced himself, as was reported in the local press of 1856:

A DRUNKEN PREACHER.- We learn that at Longton Church, on Sunday last, a newly-imported curate, who was to have preached a funeral sermon, was suddenly taken sick in the early part of the morning's services; some of the people supposed through the previous night's debauch; and after vomiting a quantity of filth, had to be taken from the church, and was led home, being jeered at by the boys as he passed through the streets. We hear the congregation, en masse, left the church, and his anti-teetotal Reverence has not since been heard of in the locality.

Churches have played host to a variety of talented musicians over the years, but one place of worship elected to close its doors on one performer in 1937. Tiny Bostock, the famous Leek flyweight boxer, was a fine solo singer and formerly a choirboy at All Saints' church in Leek. He sang, by invitation, at a small number of Staffordshire churches, and he was earmarked as one of the attractions at a sportsmen's service organised at High Street Methodist church, Goldenhill, in connection with the annual Goldenhill Queen's charity appeal. However, the church trustees refused to allow Bostock's involvement, believing that it was improper 'for a representative of the boxing world to take a prominent part in the service'. Bostock, responding in the local press, declared that he had been raised in a Christian atmosphere, and neither smoked nor drank. Furthermore, he had been encouraged to take up boxing by a Leek clergyman, the Revd Hugh Warren. He felt that the church was doing the world of boxing an injustice. His manager pointed out that if Bostock accepted all the requests he received to help churches and charitable institutions, he'd have no time for his boxing career. Clearly, the Goldenhill High Street church had picked a fight with the wrong man, hence this bad publicity in a local newspaper.

The subject of the church and music raised its head again, in September 1938, when the Revd V. G. Aston, the vicar of Penkhull, found himself in hot water with music lovers. In that month, he fulminated in his parish magazine on the subject of jazz music – which he described as more harmful than many of that generation's sins. He gave definitions of the music then in vogue. 'Hot Music,' he declared, was 'symbolised when an untutored savage divests himself of his clothing and executes a war-dance ... Sweet Music is symbolised when in the discreet penumbra of the one-and-tenpennies at the cinema, two lovers suck the same lollipop.' He also quoted liberally from an article he had read, criticising such music. There

was a feisty reaction from readers of the *Newcastle Times* newspaper. W. E. Park, the leader of the Majestic Ballroom Band, Hanley, said of Aston's definitions that they read like 'the meanderings of a pre-adolescent mind, as inaccurate as they are unintelligent'. Len Prince, the leader of the Castle Hotel Orchestra, Newcastle, reasoned that Aston was well known as a pantomime producer – he produced the Penkhull Belles show – and that his remarks were to be taken in the spirit of pantomime. He questioned Aston's definition of 'jazz' and asserted that the vicar was 'talking through his clerical headgear.' Len guaranteed to put up a better show in delivering a Sunday sermon at Penkhull, than Aston could do, playing the trumpet. A few other correspondents sided with the vicar, though one noted Longton pianist compared jazz melodies with church music: 'For real maudlin sentiment, false rhyming and inaccurate scansion I would refer him to many of the hymns that go up, more or less tunefully, upon any Sunday of the year.'

Aston found himself forced to write a lengthy letter of reply, in which he stated – quite accurately – that the original *Newcastle Times* report of his 'outburst' was so badly punctuated that it was difficult to tell whether it was he or the article he'd read that was being quoted. Aston's letter – when read in full – squirms a little, though he still musters the courage of convictions to respond robustly to his critics. Considering the popularity of bands and ballroom music at this time, he was certainly risking trouble in broadcasting anti-jazz opinions – whether they were his own or those he'd read.

The accompanying photographs of a high-profile funeral in Burslem were recently loaned to Burslem History Club. Even if the viewer is not curious about the occasion itself, he or she may be interested in the Market Place street scene, dominated by the Leopard public house and James Cock's shop. The photographs are a classic example of the precious items that are stored, gathering dust, in someone's loft for decades, but are subsequently rediscovered and widely appreciated. The only trouble is, all too few people write captions and dates on the back of photographs. It was therefore necessary for *Secret Stoke-on-Trent* to undertake detective work in order to put some paint on the canvas.

Research shows that the photographs relate to a significant occasion in Burslem: the funeral of Monsignor Browne, the Roman Catholic priest of Burslem, in October 1956 – he was eighty-eight. Having been born in southern Ireland, he pursued his early career as a priest in Birmingham before coming to the Potteries in 1901, being sent as a curate to Hanley. Four years later, he went to Goldenhill as a parish priest. He became parish priest in Burslem in 1908, but at this time there was no proper church and the parish was heavily in debt. However, Browne proceeded to pay off existing debts and to raise funds for a new church – which was to be his crowning achievement. St Joseph's Roman Catholic Church was opened in 1927. His other achievements in North Staffordshire included the guiding in spiritual care of the Smallthorne area – until it became a separate parish – and the establishment of a parish at Wolstanton. For his funeral, a 500-strong funeral procession made its way through the town from St Joseph's church to Burslem municipal cemetery, where Browne was interred. It was attended not only by high-ranking Catholics from all over North Staffordshire, but school pupils, parishioners and mourners from all over the city.

Lastly, what of the churchyards of Stoke-on-Trent? Many of them have fascinating tales to tell and are of immense interest to the social historian. In Burslem, the churchyard of St John's church is famous – or infamous – for being the last resting place of 'Molly' Leigh, the

St Joseph's Roman Catholic Church, Burslem, 1994.

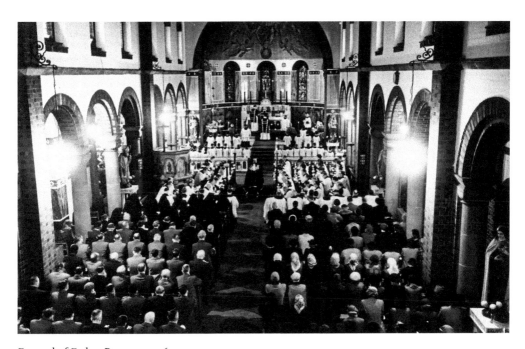

Funeral of Father Browne, 1956.

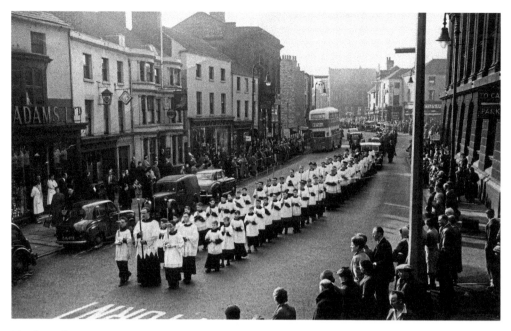

The funeral procession.

Carrying the coffin.

Above left: Mourners at the funeral of Father Browne.

Above right: St Paul's Church, Dale Hall, demolition in 1974.

alleged Witch of Burslem. The facts and the fiction in regard to Margaret clash stridently, though the popular myth refuses to die. It is interesting however that in perpetuating the ghost story of Molly Leigh, fans of the supernatural have overlooked a ghoulish episode that appalled respectable Burslem people in 1831.

The *Staffordshire Mercury* reported that several of the graves of the recently interred had been reopened. Two men had been observed with spades and a lantern in the churchyard, but they had been disturbed in the process of accessing the graves. The local press wrote of 'Resurrectionists in the Potteries' and reported that one body had been bagged and taken to an adjoining field, and the body of an infant had been removed from a coffin but not packed. A reward was offered for information leading to the capture of these men. The newspaper remarked that it was high time that the government legislated for the supply of items for dissection to the surgical profession. At the time, many surgeons were relying on the dirty deeds of bodysnatchers.

Eventually, one of the perpetrators, John Watts, was apprehended in his native Birmingham, and identified by the Newcastle-under-Lyme joiner who had made the deal boxes for his grisly booty. He had already served various sentences for stealing dead bodies. He was committed to Stafford Gaol, where he died of consumption.

Recreation

Over the years, there have been many places of resort in the Potteries. Some still thrive, and some are long-forgotten and barely mentioned, even by knowledgeable researchers. Who now would mention such obscure venues as the Three Harrows Music Hall in Tunstall, the Britannia Theatre in Burslem or the Alma Theatre in Longton?

Then again, entertainment of all kinds was widely available before the advent of purpose-built venues, as many buildings were multifunctional.

Burslem's first town hall offered amusement courtesy of the ventriloquist, Mr Newman, in 1839. He was nothing if not extremely versatile. It was advertised that he would

> give his imitation of a Gang of Smugglers landing their cargo; there will be eight or ten different voices heard at the distance of one hundred yards. He will also give his imitation of a Gang of Thieves leaving a Wood; there will be eight or ten different voices heard at a distance of 100 yards, as if they were coming to the town. He will also relate his travels in America, and different parts of the Globe. He will also give his Imitation of Hornets, Bees and Wasps, which he performed with great satisfaction before his late Majesty, at Brighton.

Eventually, however, purpose-built arenas and auditoria were established for the amusement of the populace. Batty's Circus in Tontine Street, Hanley – mentioned in the Victoria County History – was one such entertainment magnet, but you have to delve deeper in order to

Black swans on Westport Lake, near Tunstall, 2013.

learn more about the bizarre acts that sometimes appeared there. In 1887, this establishment advertised Mademoiselle Victorina, who was reputed to be the strongest woman in the world, and billed as the Beautiful French Lady Hercules. *The Sentinel* reported that she carried weights of 600 pounds and had a cannon, weighing 175 pounds, fired while suspended from her teeth. She also lifted a bank safe, weighing 8 cwt, and attempted to pull against two of the strongest horses that could be procured in the district. Upon attempting this previously, the pulling ropes had snapped, and so Mr Elphinstone, the proprietor of the Circus, had to obtain a double set of chains in order to take the strain. Incidentally, the strength and size of women at this time often had great novelty appeal, for at Tunstall Wakes in 1875:

> The fat lady also occupied a few moments of our attention. Madam Wainwright, as she is called, is of leviathan bulk; her weight of about 45 stone; but the most marvellous sight was her infant, that weighed over six stone and only eighteen months old. We saw the mother, but were not gratified with a sight of the father...

Batty's Circus was one of many that entertained the public, but other, similar attractions were itinerant, making regular visits to the Potteries. There is an interesting incident relating to the visit of Bostock and Wombwell's menagerie to Hanley in 1872. The show had been set up in Market Place, but an elephant and some camels had been accommodated in the old stable yard to the rear of the Angel Inn. The animals had attracted the attention of some children, who gained access to the yard and began to feed the elephant nuts – 'and other

things' including stones. The pachyderm took umbrage, and seized one boy, George Stanton, winding her trunk around him. She then crushed him against a wall. The animal keeper arrived on the scene and ordered the elephant to drop the boy, but he subsequently died of internal injuries. So much for animals being dumb.

Where animals are concerned, it's well known that cockfighting, dogfighting and bull and bear-baiting were organised in the Potteries – but we have a very rare reference to rat-baiting in 1867. This occurred at the Wedgwood Arms beerhouse in Brickhouse Street, Burslem, courtesy of John Miller, the beer seller. The police court reports tell us that a police superintendent had gained access to a room upstairs where around fifty people had paid sixpence admission each, in order to stand around a stage in the centre of a room. On the stage was a rat pit covered with wire gauze. Rats were taken from an iron cage and thrown into the pit, and there chased and killed by dogs. The activity was of course illegal, despite the fact that Mr Miller had actually advertised the event through hand-bills, boasting that he had 'the finest raised stage in England.'

Brutal sports in the Potteries died hard, and men fought for any number of reasons – perhaps to settle a dispute, or more usually for a winner's purse. Reports of pugilistic bouts are plentiful in nineteenth-century newspapers, and it was not unknown for women to do battle, as was seen in Cobridge in 1878. A ring was formed on some waste ground by Cobridge railway station. Two women, Brunty and Sally, tied up their hair and bared their arms to the shoulders, and then commenced to exchange punches in rapid succession. At least one of the combatants was severely bitten, but a cry of 'police' swiftly dispersed the crowd.

Another popular working-class pursuit and crowd-puller was pedestrianism. Champion long-distance walkers' feats were often described in the local press in the nineteenth century, but in due course, people began to enjoy those competitors who combined athleticism with a novelty value. At the grounds of the New Belle Vue in Basford (most lately known as the Queen's), proprietor Henry Platt organised all sorts of athletic competitions. In 1866, he introduced Edward Thomas, the Northern Deer, who undertook to walk half a mile forwards, half a mile backwards, run half a mile, hop 50 yards, pick up twenty stones a yard apart, and bring each one separately in a basket, pick up twenty bricks a yard apart with his mouth, and bring them separately to one end. It was stated that he would perform these feats within the brief time of twenty minutes. The day after, he was scheduled to walk 3 miles forwards and 3 miles backwards in under an hour. Mr Platt also advertised gymnasts, Chinese jugglers and balloon ascents, but young Thomas may well have been the star attraction.

One notable present-day long-distance walker is Keith Meeson, born in 1945, who still accumulates many miles for charitable causes. As Keith admits, many of the ideas for his long-distance walking stunts are hatched in his local pub, the Rose & Crown in Stanley. In this sense, Keith can claim to be the natural successor of Frank Swinnerton. Frank was the head of a leading catering firm in the Potteries, and in 1932, someone in his local club bet him that he couldn't walk from Stoke to Worcester – a distance of 64 miles – in twenty hours. He trained for a month before attempting the feat. He began from Stoke at midnight on a Saturday, and headed off through Stafford and Wolverhampton. He arrived in Worcester with an hour and forty minutes to spare. Like Keith, he made sure to recruit a support team, being accompanied by four pacers, a masseur, a chiropodist and a van fitted

Queen's, Basford, 1996.

Keith Meeson and Mervyn Edwards involved in a charity walk along the Caldon Canal – 'Clogging It Up The Cut,' 2009.

up with a portable bed on which he could rest.

For those who enjoyed more leisurely walking, the Potteries parks were perfect – and on occasion, it was also possible to see something curious or eye-catching in the parks. For instance, in February 1919, you could have seen three captured German guns in Burslem Park, Longton Park and Hanley Park. Indeed, Hanley Park could boast of a very interesting relic that still survives – though it is to be found elsewhere. This was the iron gravestone of John Smith (dated 1614), son of Alderman John Smith. It had been sold as scrap by St Giles' church in Newcastle to Kirk's foundry at Etruria in 1874. It was ultimately given as a gift to the park by Alderman Shirley and was placed by the 'dingle', where it remained until 1911, after which it was returned to its rightful home in St Giles' churchyard.

A large recreational area for Hanley was a long time in coming, with evidence suggesting that the plan was first considered in the 1840s. Hanley Park ultimately opened in two parts, in 1894 and 1897, after years of discussion about a suitable site for it – but what if history had taken a different turn? Astonishingly, there were suggestions in the *Staffordshire Knot* newspaper of 1882 that a park for Hanley might be made on 'the waste land at Wolstanton'. Presumably, the marsh was suggested on account of its long-time popularity with Potteries folk as a venue for foot-racing, pugilism, rabbit-coursing and other sports. How the idea of a public park on part of the Marsh would have been received by the Duchy of Lancaster – which has owned the Marsh since 1267 – is quite another matter; but it was at least being considered, as evidenced by this response from a Knot correspondent writing under the pseudonym of 'Student':

> Dear Sir, - As one of those who would like to see a park for Hanley, perhaps you will kindly permit me to pass my opinion as to the site proposed, namely the Marsh at Wolstanton, for those who require fresh air the most, to wit those who have passed the meridian of life, the distance from Hanley would be too great, particularly when the steep ascent thereto is considered, therefore the proposed locality I for one deem quite unsuitable...

The popularity of football in the Potteries has spawned numerous books on Stoke City and Port Vale by specialist writers, but coverage of the two clubs' exploits in the local newspapers has been so voluminous that it is relatively easy to uncover gems of information. How many present-day Port Vale players would take a stage and do a turn for the local community? In 1887, Port Vale organised a treat to the poor at Burslem Town Hall. It was hugely successful, as around 1,100 children turned up and were accommodated in two sittings. Poulson, the Port Vale player, recited 'The patent hair-brushing machine' and such was the youngsters' joy in seeing their heroes on stage that they demanded – and were given – a rendition of Cock Robin, which, they recalled, the team had given the previous year.

Singing at football matches was the job of spectators, though – and in 1920, Vale's new supporters' song was launched at a supporters' club smoking concert at the still extant Albion Hotel in Hanley. Its author and composer was Fred Glen, and the supporters' club chairman, the Revd A. Hurst, urged the committee members to 'Sing it to your wives and children, sing it on the ground and in the streets, and make yourself perfect nuisances with it.' Mr Baddeley, the club's secretary, conveyed that copies of it would be sold at 6d each and offered for sale at the following Saturday's match against Hull City at Vale's headquarters,

Longton Park lodge, 1999.

Tunstall Park boathouse, 2013.

Port Vale Legends, 1953/54. Pencil drawing by
Mervyn Edwards.

Alan Massey, Brian Purcell and Margaret Clarke at the Port Vale *v.* Shrewsbury football match, 2013.

Richard Booth, of the GMB trade union, with
Port Vale's Carl Dickinson, 2015.

the Old Recreation Ground. There was even a band lined up to play the song during the afternoon. The song was certainly efficacious, as Vale beat Hull 4-0.

Port Vale's neighbours Stoke City have, in the past few years, enjoyed an upsurge in their fortunes, and have even sampled Europa League football. However, back in the 1960s, it was the belief of then-manager Tony Waddington that his players would benefit from travelling abroad and playing top teams. Largely forgotten is a match away to Moscow Spartak in 1965. Stoke's team was thefollowing: Leslie, Asprey, Skeels, Palmer, Kinnell, Bloor, Dobing, McIlroy, Ritchie, Vernon, Burrows. Nearly 100,000 people watched the game, which Stoke lost 1-0. A report in the *Evening Sentinel* newspaper came courtesy of the Soviet news agency, Tass, a reminder of the times we lived in.

What of the gentler game of cricket? It's no secret to fans of the bat and ball that the West Indies played Staffordshire at the County Ground, Stoke, in 1928. What's less well known is the degree of excitement that the fixture triggered, while the way in which it was reported may also interest the politically correct element in today's society. The *Staffordshire Advertiser* conveyed that of the seventeen touring players, only five were 'whites,' the rest being 'coloured natives of the West Indies'. Their appearance in the field was said to be 'novel' and their energy and enthusiasm 'exhilarating'. Over two days, a record figure of 10,000 people crammed into the ground to watch the match, which was such a spectacle that the *Advertiser*'s cricket correspondent scribed that he had never seen anything like it in his fifty-five years of watching the game. It was won by the tourists.

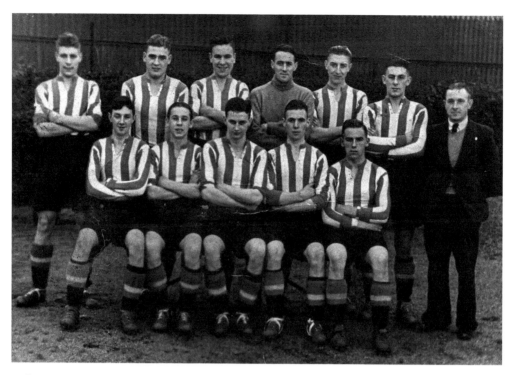

Stoke City A team, 1938/9 season.

Stoke City *v.* Genoa, pre-season friendly, 2013.

Public Houses

Welcome to the crazy world of pubs and beer. If all the world's a stage, then our Potteries watering holes – with their all-star cast of memorable publicans and dubious patrons – certainly created something akin to theatre in the days when hundreds of street-corner pubs teemed with beer-guzzling, raucous roisterers.

As social hubs, public houses were just as valued as churches and chapels – though it might be said that some folk worshipped drink just a little too much. Take the case of Mary Hall, who was brought before the Longton police courts in 1866 on a charge of drunkenness. Described as 'a wretchedly forlorn looking woman of ninety-six years', she had been found by a policeman lying near to the toll gate at Longton, drenched to the skin by rain that was still coming down in torrents. The only clothing she had on was a shawl over her shoulders and a piece of skirt around her legs. Mary was taken to a police station and sat in front of

Abbey Inn, Abbey Hulton, 1908.

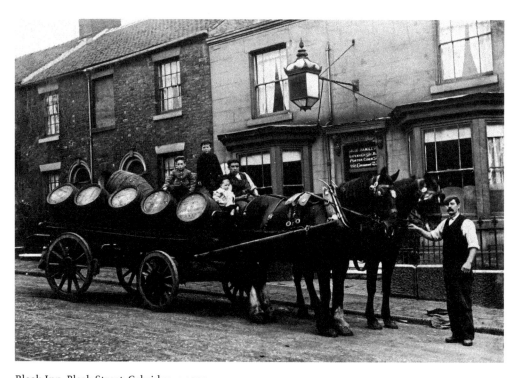

Bleak Inn, Bleak Street, Cobridge, *c.* 1903.

a fire in the kitchen to dry out and sober up. The court heard that she had been had been wandering the district for the last twenty years, 'always appearing in the same state as she was that morning'. Having had sympathetic friends, she had somehow managed to avoid the workhouse, and the court, perhaps because of her age, ruled that she was more sinned against than sinning and decided to send her back to her Congleton home by train. Upon leaving the dock, the nonagenarian said, 'Thank God I have as good health as ever as I had in my life.'

Pubs not only attracted colourful customers but on some occasions were run by larger-than-life landlords. In 1892, Mr Hardy, the publican of the Queen's Head in Burslem, entered a den of four wolves attached to Sedgwick's Menagerie, which was visiting the town. Accompanied by Lorenzo, an animal tamer, he was allowed to put the animals through various exercises. They jumped through hoops and leaped over his leg, arm and head, as the apparently nerveless Hardy took applause from the audience. He was duly praised by Lorenzo, as being the only man who had ventured into a cage of wild beasts with him. Francis H. Wolfe, the landlord of the Roebuck Hotel in Longton, pulled a similar stunt in 1901, for a £5 bet. He entered a lion's den at Collins' African Menagerie, which had come to town for the Shrovetide Fair. When the lioness saw her tamer entering her cage with a complete stranger, she leapt from one end of the cage to the other. However, Wolfe stood by the tamer's side for some minutes while the audience cheered. He won his bet, and was accompanied by a large crowd of people as he walked back to the pub for what was very likely to have been an evening of justifiable bragging.

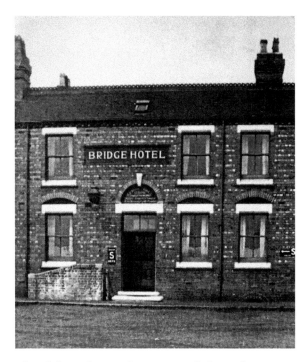 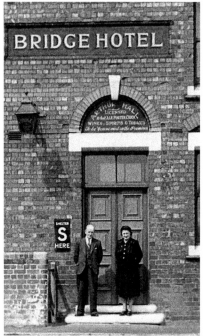

Above left: Bridge Hotel, near Tunstall, date unknown.

Above right: Bridge Hotel, near Tunstall, 1940s. See notice for air raid shelter.

Most landlords would have viewed entering wild animals' cages as unnecessary danger. The pub trade could be hazardous enough at the best of times. In 1846, the landlord of the Marquis of Granby in Burslem was brewing some ale, when his assistant, James Heath, stumbled and fell into the boiling liquid in a mash tub. The landlord rescued Heath from the tub – scalding himself in the process – but he later died in the North Staffordshire Infirmary, after lingering in great agony. Many other pubs witnessed tragedy. The 1871 census shows that Hugh Heath and his wife Elizabeth were keeping the Dog & Partridge in Cobridge. However, the pair had been unhappy for some time, partly on account of the intemperance of Elizabeth, and in the same year, Elizabeth committed suicide by drowning. Her body was found in a cistern in the back yard of the pub.

How about the following for a pub crawl with a difference? In 1871, the local press reported on an 'extraordinary mock funeral' in Stoke. It appears that the wife of a Stoke tradesman had informed against and obtained the conviction of several publicans for supplying beer to her husband at improper hours. Six people duly decided to scoff at the episode and subsequently took part in the mock funeral. They placed an effigy on a board, covered it with a white sheet and took it on a tour of several Stoke pubs in High Street, King Street, Liverpool Road and London Road. Police constable Oldacre had witnessed the men emerging from the Star Inn and placing the board and effigy on their shoulders. One man tinkled a bell, another dressed as a clerk, and yet another was attired as a parson, wearing a gown and college cap. This man walked at the head of the procession, reading a book that was held open before him, and the 'cortege' proceeded to move along several main

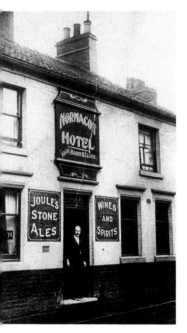

Above left: Normacot Hotel, Normacot, early twentieth century.

Above right: Rebuilt Normacot Hotel, now a shop, 2012.

streets. They were followed by a crowd of between 300 and 400 people, who heard the bogus parson read a few phrases from the book, of which the most audible was 'Man that is born of woman.' When the King's Arms was reached, a jug of beer was brought out for the bearers, while the parson and the clerk stayed inside for eight minutes – by which time the street was completely blocked up by the procession. The 'mourners' then left the King's Arms, followed by the still-swelling crowd, the parson still solemnly tinkling a bell. The next port of call was the Cock Inn, into which the effigy was actually taken. All of the pubs at which the funeral procession called had been fined a fortnight before by the court. The men who led the mock funeral now fined themselves for wilfully impeding and obstructing free passage of persons in the main streets and for their disorderly conduct.

The names of pubs have charmed, amused, confused and annoyed drinkers over the years. Some of the old beerhouses had quirky names, for example, the Why Not in Burslem, the Big Pig in Longport and the Mistletoe in Northwood.

If you look closely at the accompanying photograph (c. 1903), you'll notice that the pub appears to have two names. We can pick out the name of the White Hart below its pediment, while the etched windows declare that it is the Victoria Hotel. At the Burslem licensing transfer sessions in 1930, the pub is referred to as the Victoria Inn, but ongoing confusion over its name saw the matter being discussed by Burslem Police Court in 1934, as reported in the *Evening Sentinel*, which ran a story headed, 'Inn With Two Names.' The organ declared that nobody seemed to know what the correct one was, and on this occasion, the opinions of the licensing magistrates, the police and the brewery were all sought – without really settling the matter. The discussion was triggered by an application to the magistrates by Thomas Wood, the licensee of the Bell in Eccleshall, for temporary authority in respect of the licence of the Liverpool Road pub. When the assistant magistrate's clerk asked what the right name of the pub was, Chief Inspector Marshall opined that as the name of the White Hart was carved in stone on the frontage and then this should be the proper name. This was the name given in the clerk's records, too, but he'd received a letter from the brewery referring to it as the Victoria. A brewery representative declared, 'We don't know it as the White Hart. We took it over from another brewery as the Victoria and the Excise licence and records call it the Victoria.'

The clerk himself – who actually thought that the name of the White Hart was 'a jolly sight better' but concurred with the meeting's chairman, J. Wilcox that only one name should be used – and stuck to! Wilcox was happy to grant the application, but insisted, 'We think that either the hotel should go back to its name of the White Hart, or steps should be taken to have it registered as the Victoria, so that it will appear in our records as such.'

The Sperling in Norton was demolished years ago, but people often wondered what on earth the pub's name referred to – an exotic bird, perhaps, or a famous steam locomotive? Sadly, the explanation is prosaic. It was opened by Ind Coope Ltd in 1960 and was named after Mr R. Sperling, a director of the company. So the name of the new hostelry was merely an exercise in corporate tub-thumping and self-regard.

The company perhaps might have considered asking those likely to patronise the pub for their suggestions on the naming of the hostelry. Readers of *The Sentinel* newspaper were responsible for naming both the Old Sal in Adderley Green, Longton and the Weathervane at Meir Park. The pubs were opened in 1984 and 1998 respectively.

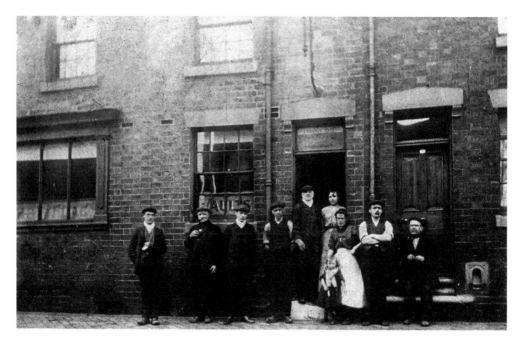

Lamb and Flag, Northwood, date unknown.

Foaming Quart, Burslem, 1970s.

White Hart, Westport Road, Burslem, probably 1903.

Huntsman, Westport Road, Burslem, probably 1970s.

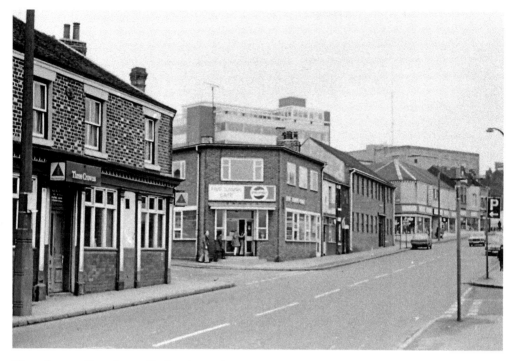

Three Crowns, Hope Street, Hanley, date unknown.

We now conclude *Secret Stoke-on-Trent* with a few thoughts on how some secrets remain so forever.

There was once a pub in Hill Street, Stoke, called the Greyhound. It was kept by Albert and Florence Baddeley between 1955 and 1959, but demolished in 1964. However, a glass door pane depicting the eponymous greyhound was rescued from the remains, and kept in cold storage by the Baddeleys' daughter, Jean. Many years later, she approached yours truly for ideas on how the glass picture might be put on public display. We eventually mounted and framed the item, and placed it on what we hoped would be permanent display at a wholly appropriate venue. This pub was less than half a mile from where the Greyhound had stood – and had the same name! Jean was delighted to be present at the unveiling at the Greyhound in Manor Court Street, Penkhull, in 2008. The aged picture's relocation after so many years was a terrific story that the *Sentinel* newspaper was happy to cover. However, the Greyhound has known many vicissitudes in recent years, and tragically, the item went missing when the pub changed hands – never to return. Jean and I made a public appeal for information leading to the return of the item – to no avail. Its whereabouts remain a mystery, and it might even be preferable not to know what became of an object that had such great sentimental value to the Ridgway family.

Here's another matter that has mystified us for some time. Several years ago, a poem was left in the Golden Cup in Hanley. It was a simple enough piece of work, but came from the heart of an amateur poet, 'Geebee'. Vigorous efforts to ascertain his true identity failed, but here is the poem, reproduced here as a treat for all of us who have sat in boozers trying to make sense of the secrets of existence:

GOLDEN CUP

In this pub I spent some of the happiest nights of my life
With the best of friends, the best of ale and the best of emotions
Time is forever changing, but this place holds memories, feelings and an aura for me which
can never be removed
I have travelled to many places, done many things, and experienced many emotions
But today, being back in this seat has revived feelings, emotions, thoughts and pictures in
my mind that I thought were not there anymore.
This place inspired me, saved me, warmed me and WAS me for many years
It is twenty years since I last sat on this seat and if it is twenty years hence until I do again,
I know that it will still feel just as good.
Time is precious, so seize the day - Carpe Diem - be yourself. Such places as this are precious.

God Bless, GEEBEE (11/5/98).

Ackowledgements

My thanks go to Jean Adams, Linda Boulton, Kevin Breward, Bob Cooper, Laurence Davidson, Jim and Pam Dutton, Kenneth Edwards and family, Bill Harrison, Miss Holdcroft, Glyn Kelsall, Alan and Linda Massey, Bernard Lovatt, Doug Millington, Gerrard Moseley, Paul Niblett, Philip John Rowley, Alan Salt, *The Sentinel* newspaper, Ian Sutton, Gary Tudor, the Warrillow Collection at Keele University Library, Alan Whitehead ... and especially, Ewart Morris.

Every effort has been made by the author to correctly identify copyright owners of the photographic material in this book. If, inadvertently, credits have not been correctly acknowledged, we apologise and promise to do so in the author's forthcoming book for Amberley Publishing.